IMAGES
of America

TELLURIDE

IMAGES
of America

TELLURIDE

Elizabeth Barbour and
the Telluride Historical Museum

ARCADIA
PUBLISHING

Published by Arcadia Publishing
Charleston, South Carolina

Printed in the United States of America

Library of Congress Catalog Card Number: 2006926069

For all general information contact Arcadia Publishing at:
Telephone 843-853-2070
Fax 843-853-0044
E-mail sales@arcadiapublishing.com
For customer service and orders:
Toll-Free 1-888-313-2665

Visit us on the Internet at www.arcadiapublishing.com

This book is dedicated to Alexandra Grace DeFelice.

CONTENTS

ACKNOWLEDGMENTS

Many thanks to the Telluride Historical Museum for preserving the photographic archive that brings these pages to life. I am indebted to the museum board of directors for allowing its use, and to Lauren Bloemsma, executive director of the museum, and Sonchia Jilek, assistant director, for generously committing time, expertise, and knowledge in the form of invaluable editorial suggestions. The Telluride Historical Museum is grateful for a grant from the Colorado Historical Society that enabled it to digitize a large portion of its extensive photographic archive. Because of this grant, the public can access the photographic archive online at www.telluridemuseum.com.

The Telluride community and members and volunteers at the Telluride Historical Museum are commended for supporting the museum since its beginning in 1966, thereby allowing the museum to preserve and promote the uniquely rich historical significance of Telluride and the surrounding region. Housed in the recently restored Old Miner's Hospital, a historic landmark completed in 1896, the Telluride Historical Museum hosts dynamic exhibits using their collection of diverse artifacts, photographs, scrapbooks, and other items to interpret local history.

Recognition is due to 19th-century photographers Joseph E. Byers, W. J. Carpenter, and others for creating a priceless, palpable, and exciting visual record of Telluride and the surrounding area when photography was not as easily achieved as it is today.

Stories told to me by William "Senior" Mahoney, the oral histories in Davine Pera's compilation, and reflections of early life in and around Telluride recounted by authors Harriet Fish Backus, Alma Mary Midwinter, and Evelyn Gustufson Eggebroten constitute the heart and soul of this book. Special thanks, also, to Jack Pera for his information and suggestions.

The staff of the Wilkinson Public Library was helpful during my research. It is laudable that the library and the Telluride community worked together to establish The Telluride Room, a tremendous resource for anyone studying Telluride.

I am grateful for support and guidance from Christine Talbot, my editor at Arcadia Publishing.

Lastly I thank my mother, Nancy O'Dell Barbour, for teaching me how to write; my father, Stuart Acree Barbour Jr., for imbuing me with a love of history; and my husband, Charlie DeFelice, a Telluride resident since 1970, for sharing his wealth of tantalizing tales of Telluride.

I apologize in advance for any discrepancies found herein. Unfortunately "facts" available to researchers frequently differ from source to source.

INTRODUCTION

Telluride, Colorado, is a remarkable jewel in the crown of the Rocky Mountains. Her record reflects overarching themes in the nation's economic and social history. These factors, coupled with an architectural landscape that preserves the legacy of the American West's fabled mining era, resulted in Telluride being declared a National Historic Landmark District by Congress in 1963.

One of the loveliest places on earth, this small remote town, 8,750 feet above sea level, is surrounded by soaring 14,000-foot peaks and dazzling ridgelines. The flat Telluride valley begins at the top of Keystone Hill and ends six miles to the east in a narrow box canyon where precipitous cliffs rise and waterfalls descend like blue ribbons—except when frozen in winter's grip. For centuries, the Telluride valley was sacred to the Ute Indians who traveled there in the summer months to hunt. Then in the early 1800s, fur trappers pillaged beaver dams on the banks of the San Miguel River, which meanders east to west through the valley.

It was in the late 1800s that gold was discovered in the high country. Fortune seekers entered southwestern Colorado with sights set on Telluride. As the last spikes of Rio Grande Southern Railroad were driven in 1891, trains made their way to town allowing the rush to reach its full swing. Telluride teemed with miners, prospectors, mine managers, bartenders, gamblers, bankers, engineers, and lawyers. Main Street bustled with businesses supplying goods to the high country and providing services to townspeople. There were two distinct saloon cultures—bawdy and cosmopolitan. Benevolent societies, a hospital, a school, and banks served as town anchors. Families grew and residential streets multiplied. Interestingly taxes levied on the women of Telluride's red-light district are thought to have contributed more to the town's coffers than any other local industry. Fueling the engine were countless tons of valuable ores extracted from the high country by poorly compensated laborers, many of whom were European immigrants, while mine owners lived in splendor, dined lavishly, and traveled widely.

Telluride's golden era was in the 1890s when it was known as the "City of Gold." It survived the silver crash that followed the repeal of the Sherman Act in 1893—just one display of its resiliency. How many millions of dollars were made in gold, silver, copper, lead, zinc and other rich bounty is incalculable, but no one argues the extraordinary quality and seemingly endless quantity of the hard-rock ores of the area.

Economic strife reared its ugly head in the late 1890s to culminate in a pattern of strikes that weren't resolved until 1904. By this time, gold had been found in Alaska and South Africa, shifting mining interests elsewhere. Soon after came World War I and a disaster of dramatic proportions—the influenza epidemic of 1918 that claimed 10 percent of Telluride's population. By 1929, mining was all but dead in the Telluride region, and as the Depression years rolled on Telluride grew quiet. One characteristic that has never wavered in Telluride is the optimism and heartiness of its residents. Spirits were high even in the decline experienced between the late 1920s and late 1960s. Mining of base metals resurged in the 1940s when the War Minerals Act was passed and continued until profitability waned and the last of the mines was closed in 1978.

Isolated, beautiful, and much like a time capsule, Telluride was discovered in the 1960s by those who sought a place to establish a new way of life far from the big cities and built on their ideals. Concurrently entrepreneur Joe Zoline set about establishing the Telluride ski area in 1968 and eventually succeeded in opening the first lift in 1973. Today Telluride is an acclaimed destination for skiers, outdoors enthusiasts, connoisseurs of every variety, and those seeking natural beauty and renewal. In town, Telluride's history can be appreciated in the modern comfort of a resort community. In the rugged high country, skeleton-like remains of the mining camps that made Telluride both famous and rich, whisper to visitors through thin mountain air.

One

THE CITY OF GOLD

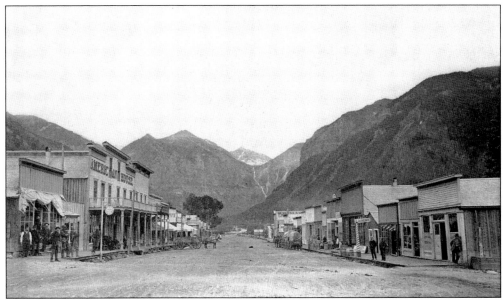

COLORADO AVENUE, LOOKING EAST, 1884. Telluride looks today much as it did in this photograph from 1884. Ajax Mountain crowns the famed box canyon, Ingram Falls runs full, and shopkeepers stand ready. The American Hotel was the most prominent building in town and the leading hotel of the era. The town, at 8,750 feet above sea level, was originally named Columbia when established in 1878. The United States Postal Service requested the town change its name to alleviate confusion caused by the existence of a Columbia, California. On June 4, 1887, postal authorities endorsed "Telluride," named for the element tellurium often found with gold and silver as a "telluride." The original settlement of San Miguel City, just west of Columbia on the valley floor, was considered expensive with its $15 lots when the Columbia town fathers cleverly platted $3.50 lots. San Miguel City lost favor as a result, and today nothing remains of the early settlement.

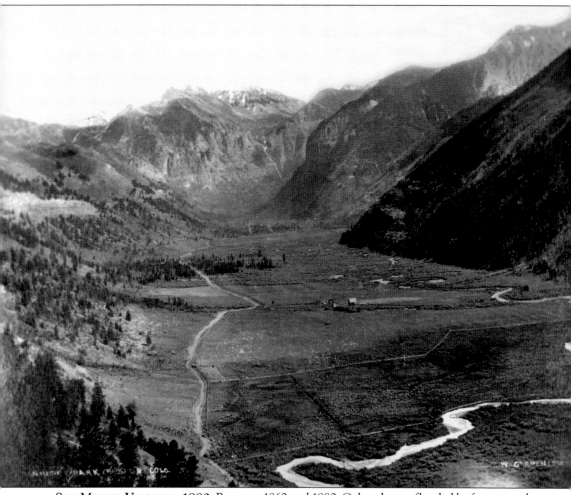

SAN MIGUEL VALLEY, C. 1880. Between 1860 and 1880, Colorado was flooded by fortune seekers. In 1874, the Hayden Survey group mapped the San Miguel Valley, seen here, with a road tracing the north side of the valley floor. A house and several outbuildings are pictured in the environs of early-day San Miguel City, the area first settled in the region about two miles west of present-day Telluride. The valley starts at the top of Keystone Hill and ends six miles to the east in a scenic box canyon.

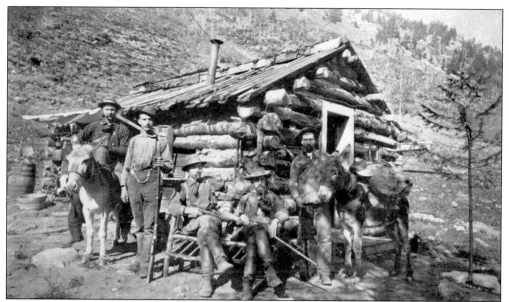

WEBB PARTY AT TELLURIDE, 1884. Will Webb of Wisconsin trudged into Telluride through thigh-deep snowy mountain passes in the early 1880s. In letters home, he remarked that 26 buildings were constructed, noting lumber shortages delayed additional development. Members of his party stand beside a simple log cabin with packed mules and shotguns at their sides. It is documented that Webb once walked 60 miles to Montrose for supplies.

EARLY-DAY PROSPECTORS IN FRONT OF CABIN. Most rough and tumble early-day miners left little record of their experiences. These two dandies have yet to install the stove in their cabin built into a hillside. In 1868, the Ute Indians still had claim to the mineral-rich San Juan Mountains. However mining fervor was growing, and by 1873, mining interests had won. By 1881, the Utes were forcibly exiled to Utah.

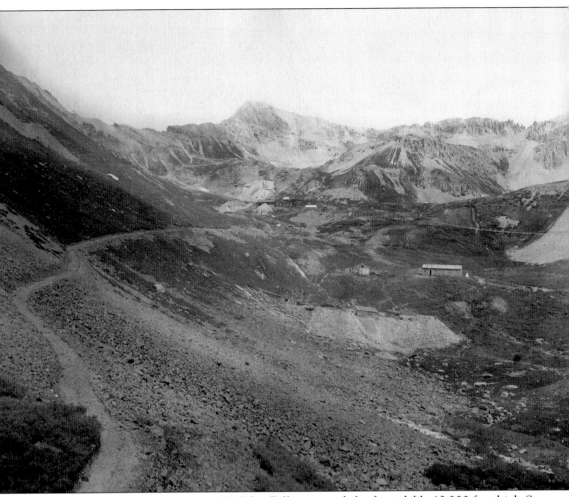

MARSHALL BASIN, 1886. In 1875, John Fallon crossed the formidable 13,000-foot-high San Sophia Ridge into Marshall Basin where he staked five claims: Emerald, Tripple, Sheridan, Ansborough, and Fallon. Each mine proved incredibly rich, giving reason for fortune seekers to make their way to Telluride. Fallon is said to have garnered $10,000, a fantastic amount in his day, from his first ore shipment.

REMINE HOUSE AT SAN MIGUEL. Brothers Bill and Lon Remine, who fought on opposite sides of the Civil War, entered the valley from the Dallas Divide around Last Dollar Mountain and hiked up the San Miguel River. When panning for gold in the 1870s, they boasted of earning $15 a day. By 1875, some 300 men had joined them in San Miguel Park, where the brothers lived the rest of their lives. They now rest side by side in Telluride's Lone Tree Cemetery.

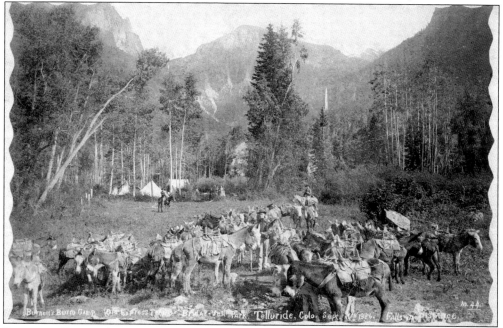

BURNETTS BURRO CAMP. At the narrow east end of the Telluride valley, great rock canyon walls rise dramatically. In summer, streams of water cascade from both Ingram and Bridal Veil Falls. In this photograph, taken on September 5, 1886, the "Express Train" waits in Bridal Veil Park to transport people and goods into the high country.

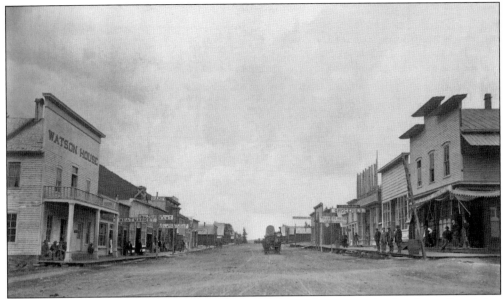

MAIN STREET, C. 1885. By the mid-1800s, wooden houses began to take the place of crude log cabins and tents. Commerce sprang alive on Colorado Avenue, commonly called Main Street, as money flowed into Telluride from willing capitalists who had faith in the mineral-rich mountains. Unlike haphazardly built mining camps, a wide main street made deliveries by teams of pack mules easy to navigate. A substantial network of boardwalks installed above the dirt streets protected pedestrians from mud and animal waste.

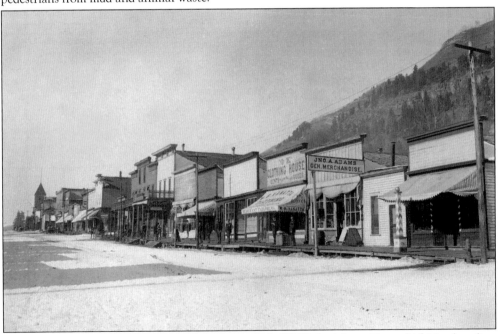

MAIN STREET, 1887. The commercial district included JNO A. Adams Genn. [sic] Merchandise, Van Atta Clothing, a barbershop, and the Sheridan Saloon Restaurant, named for the extraordinarily profitable mine in the Marshall Basin above. This photograph of snow-covered downtown looks from east to west.

ORIGINAL SAN MIGUEL COUNTY COURTHOUSE. Before the county courthouse was built, official proceedings took place in the upstairs room of a main street saloon. This first courthouse was built in 1885 on the southeast corner of Colorado Avenue at Fir Street but burned within a year.

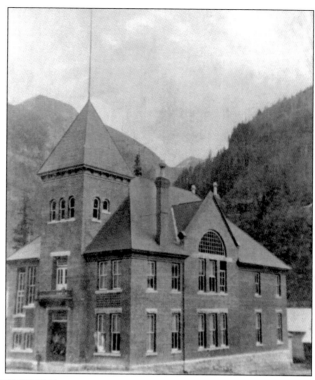

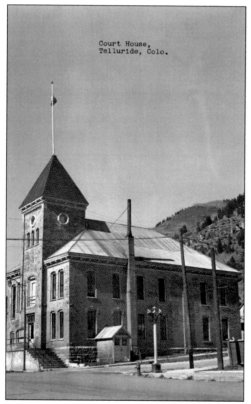

SAN MIGUEL COUNTY COURTHOUSE. The second courthouse was constructed on the north side of Colorado Avenue at Oak Street, where it still houses the county court, offices, and records. It was built of brick in 1887 and, unlike its predecessor, has the advantage of a south-facing front door—important when snowy winters cause ice on sidewalks. The community held town meetings, dances, and dinners here.

15

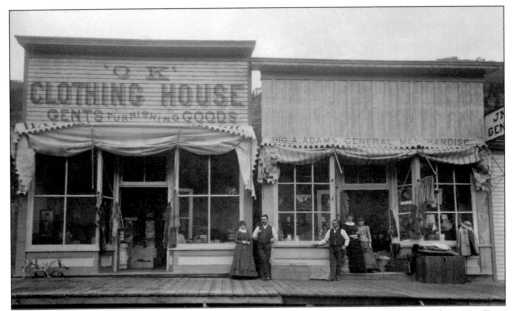

O. K. CLOTHING HOUSE AND JNO ADAMS GENERAL MERCHANDISE. Found at 131 East Colorado in early Telluride, these shops sold posters and framed art work, food stuffs in cans and jars, bedding, shoes, clothing, and much more. A large rack of antlers is seen on the wide boardwalk at far left.

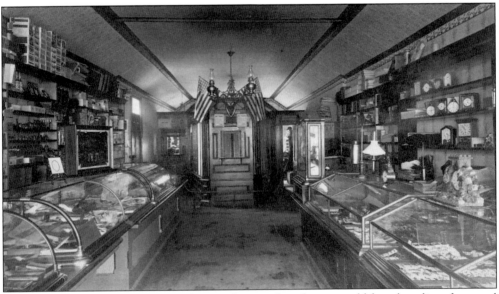

INSIDE POST OFFICE, 1890. Miners hungry for news from home would form long lines for postal services in the rear of J. B. Anderson's Drug and Jewelry Store, pictured here.

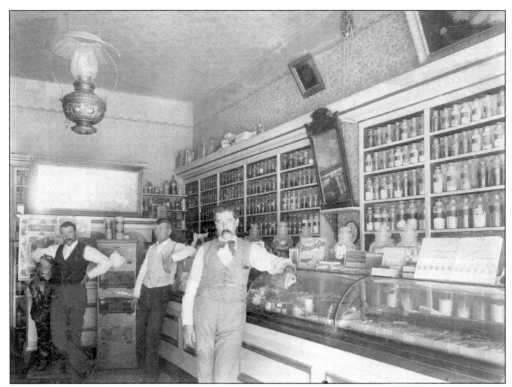

THE BUSY CORNER DRUGSTORE, 1884. Proprietor Corbin Devinie and his son sold pharmacy items and stationary, books, wallpaper, paint, and other sundry goods. Before the coming of the railroad in remote Telluride, most things, doctors included, were in short supply. Self-medication was common among the working class and miners. Newspapers of the era were filled with pharmacy advertisements for unpatented medicines in which the major ingredient was often alcohol.

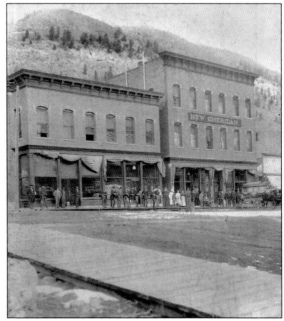

NEW SHERIDAN HOTEL AND SHERIDAN COMMERCIAL BLOCK ON MAIN STREET, C. 1900. Anticipating the coming railroad, two European entrepreneurs built the opulent New Sheridan Hotel on Colorado Avenue in 1890. It was central to Telluride's golden era and is still in operation. The velvet-curtained, calfskin-wallpapered Continental Room saw luxurious parties as violins played and guests enjoyed fine wines, champagnes, and cuisine prepared by a Japanese chef. By 1899, the hotel added a third floor and a second building. Over time, the hotel's official name has alternated between the New Sheridan Hotel and simply the Sheridan Hotel.

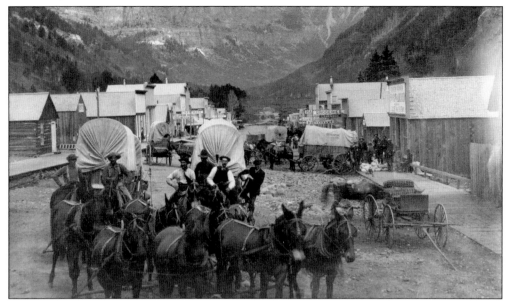

MAIN STREET, 1884. Dave Wood spent $30,000 cutting a road from Montrose to Telluride in 1882. Wood quickly covered his investment long-hauling everything imaginable (including dynamite) to Telluride in convoys of covered wagons pulled by mule teams. Merchants supplied the high country mines and miners at a fast and furious pace. Wood supplied the merchants. In addition, regularly scheduled stagecoaches ran at capacity with eight passengers inside; and many more hanging off the top.

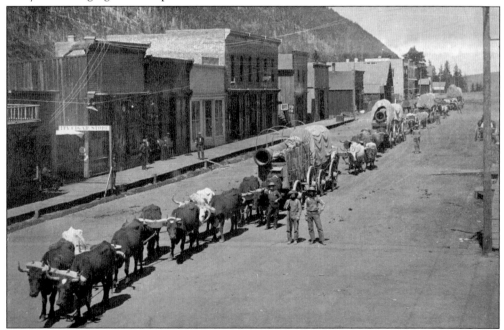

OX TEAMS ON MAIN STREET BEFORE THE RAILWAY, 1887. Without freighter Dave Wood, Telluride and the mines above would not have prospered. Woods was a central character in the success of the mining west. His daughters Frances and Dorothy recall his life in their book, *I Hauled These Mountains in Here.*

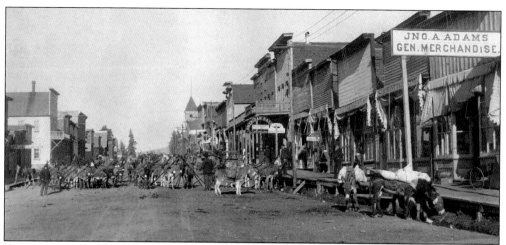

Burros Loaded with Track Iron for Smuggler Mine. Referred to as "Rocky Mountain Canaries," burros were the best animals for precipitous mining routes because of their spunk, agility, and sure-footedness. Horses were skittish and too broad to be of use on the tremendously steep, sinuous rock and talus-strewn paths that climbed into the high country. This c. 1890 photograph, looking west from Spruce Street, shows signs for the Hop Lee Laundry, Dr. Eleanor Van Atta, and the Elk Saloon. Also pictured is the San Miguel County Courthouse.

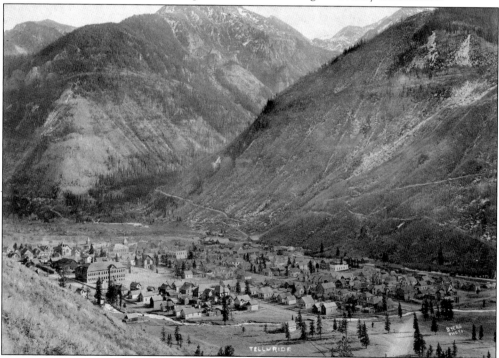

View of Telluride Looking Southeast towards Bear Creek. Residents of Telluride explored the surrounding mountains on foot and on horseback, much as they do today. Enterprising children would pack their burros with candy, travel to the high country, and sell it to miners; young women would hike to Ophir for fun; and people paid particular attention to riding fashions of the day. Ballard Peak is seen in this photograph. A mine there produced small but very fine amounts of gold.

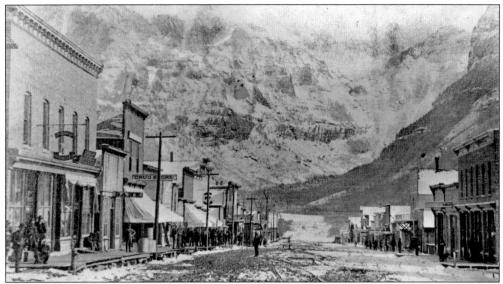

NORTH SIDE OF MAIN STREET. Robert Leroy Parker, later known as Butch Cassidy, robbed the San Miguel Bank one summer day in 1899 with some of his cohorts, the same year this photograph was taken. The approximately $24,000 stolen was never recovered despite a hearty chase by trackers following the outlaws. One of those in pursuit was bank owner Lucien L. Nunn, who brought alternating current (AC) electricity to Telluride in 1891 (see chapter six). The bank was in the small building seen second from the corner on the left side of the street.

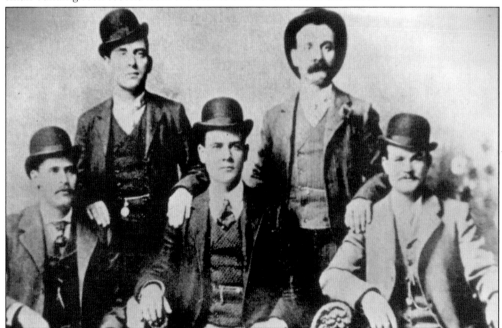

BUTCH CASSIDY AND HIS GANG. Butch Cassidy is pictured with the "Wild Bunch" in Fort Worth, Texas, c. 1900. Butch and his gang's evasive tactics confounded authorities numerous times, earning them their reputation as notorious outlaws and legends. Pictured are Harvey Logan (back left), Will Carver (back right), Harry Longbaugh, alias "The Sundance Kid" (front left), Ben Kilpatrick (front center), and Robert Leroy Parker, alias "Butch Cassidy" (front right).

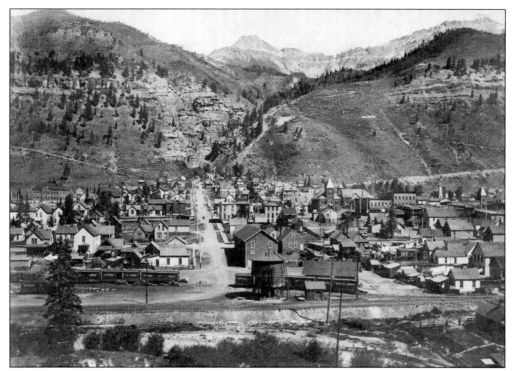

RIO GRANDE SOUTHERN RAILROAD WATER TANK. Russian-born Otto Mears, "The Pathfinder of the San Juans," dreamed of a railroad connecting Durango, Rico, Telluride, and Ridgway. The first engine chugged the narrow-gauge railroad to Telluride in 1891, impacting the town's future as nothing else could. The railroad allowed goods to move into Telluride efficiently and economically, but more significantly, her rich ores could be transported faster and farther than before. The huge, round railroad water tank stood for many years at the base of Aspen Street near today's gondola station.

RIO GRANDE SOUTHERN DEPOT, 1964. Carving its way up Keystone Hill, the railroad crossed the valley floor to reach Telluride's handsome depot. The Rio Grand Southern patented arched brackets (pictured here supporting the porch overhang) to be used in all of their depots. Its color was matched to original paint chips found on her crumbling mass in the 1990s when historic renovation occurred.

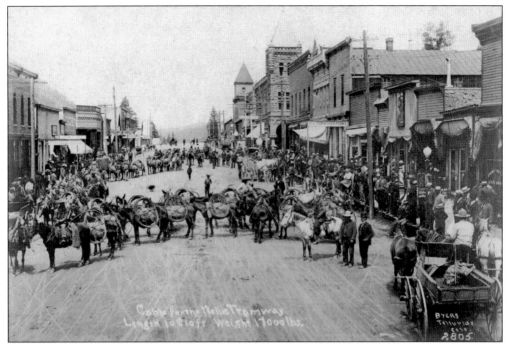

CABLE FOR NELLIE TRAMWAY. Here 10,810 feet of continuous cable, weighing some 17,000 pounds, have been wound mule to mule. In 1897, Dave Wood's mules hauled the cable up Bear Creek, bound for the Nellie Mine tramline. Even today, abandoned lengths of iron "rope" remain strewn across the high country.

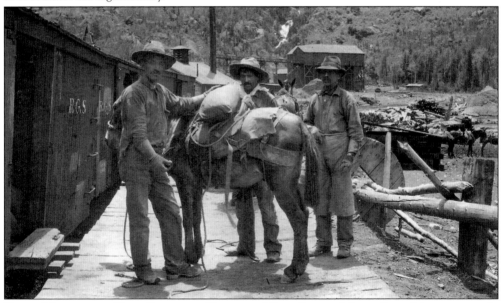

THREE MEN WITH A PACK BURRO AT PANDORA MILL. Some of the earliest claims were made east of Telluride approaching the box canyon. Originally called Newport, then Folsum, and later known as Pandora, the village developed next to Marshall Creek. The muleskinners in this picture stand beside the train on the Pandora spur with cargo that formerly would have been freighted only by mule teams.

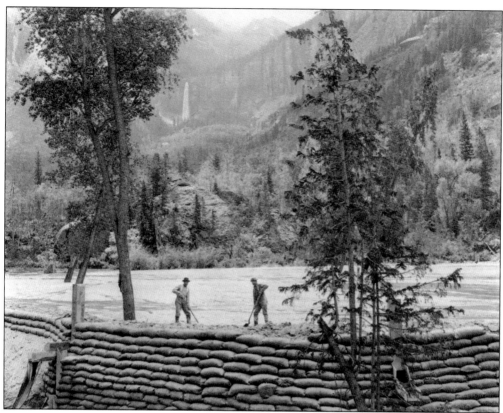

MEN AT WORK ON TAILINGS POND IN BRIDAL VEIL PARK. The material left over once ore has been pounded, pummeled, and otherwise processed to extract the pure mineral is referred to as "tailings." Mining techniques in the 1960s and 1970s produced tons of tailings, which forever altered the landscape (and presumably soil and water quality) when deposited on the riverbank between Pandora and Telluride. A superfund cleanup project in the 1990s successfully addressed these issues.

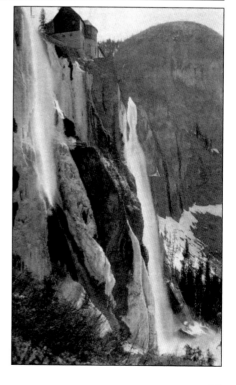

BRIDAL VEIL FALLS. Timeless beauty and grandeur fail to describe the box canyon's main feature, Bridal Veil Falls. Colorado's highest falls, it drops 365 feet. The structure seen here was built in 1907 by Smuggler Mine manager Bulkeley Wells for use as a summer residence. To appease the Smuggler Mine Board of Directors, Wells installed a power plant beneath the house that generated electricity for the Smuggler Mill below. A spectacular tram ferried goods and people between the house and the mill area. Today a private residence, the beautifully restored Bridal Veil Power Plant continues to generate hydroelectric power.

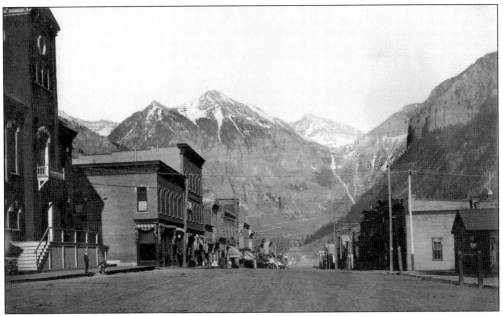

EARLY PICTURE OF MAIN STREET. The 1890s were Telluride's golden era as the mines pumped wealth into the town. Family life flourished in several different economic strata and neighborhoods of different nationalities sprang up throughout town. Several sophisticated clubs and restaurants coexisted with thriving bawdy saloons and houses of ill repute. Business directories of the time listed hardware stores, liveries, boot and shoe shops, jewelry stores, bath and barbershops, and numerous lawyers, doctors, assayers, and insurance businesses. This photograph was taken looking east down Colorado Avenue from the courthouse.

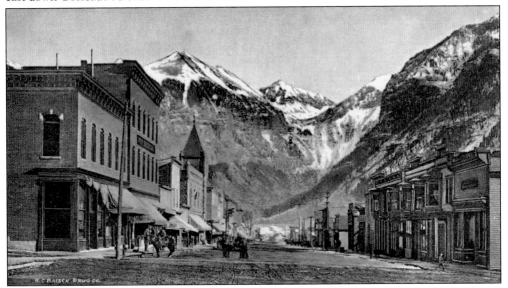

THE CITY OF GOLD. This vision of Main Street, still intact today, makes clear why Telluride was declared a National Historic Landmark District by Congress in 1963. The town's architectural landscape is of extraordinary significance in understanding how the West evolved economically and socially. Telluride maintains this high distinction with a strict architectural design review process to protect its architectural integrity for the generations to come.

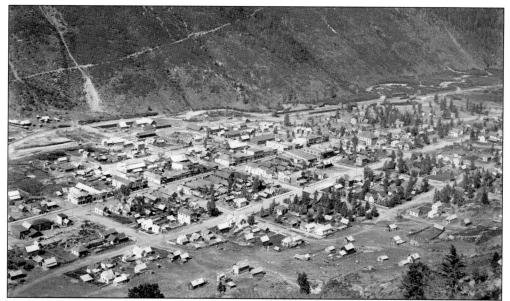

VIEW FROM TOMBOY ROAD, 1892. The railroad had a significant civilizing effect on Telluride. The population grew rapidly as more women and children arrived. Consumer goods, now plentiful, made life more comfortable. The consolidation of mines by mining conglomerates increased profitability, and the very first commercial use of alternating current (AC) electricity earned Telluride's reputation as the brightest of mining towns. However conditions at the mines were not as cheery and unrest was brewing.

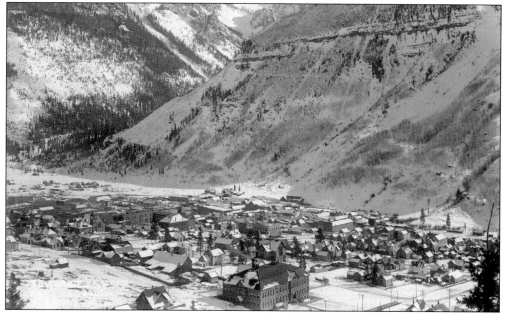

TELLURIDE IN WINTER. Census data shows Telluride's population in 1900 at 2,446 and San Miguel County's at 5,373. The census may not have counted everyone, particularly minorities who were often overlooked. There are claims of Telluride having close to 5,000 inhabitants in the 1890s. The truth remains a mystery. The prominent school building in the foreground was constructed in 1896 to accommodate the growing population.

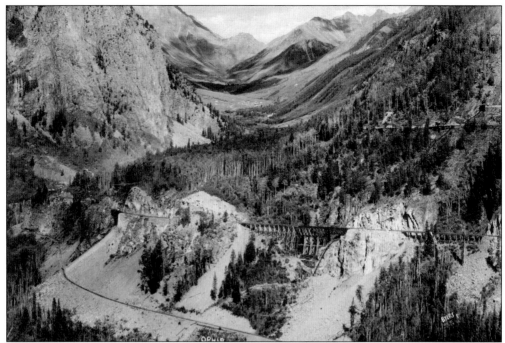

OPHIR REGION OVERVIEW, 1908. Steep, austere, and avalanche-prone Ophir is Telluride's neighbor to the southwest. The Ophir Loop was a feat of engineering accomplished by the Rio Grande Southern Railroad. Its narrow-gauge rails and sinuous trestles made service between Telluride, Ophir, and Rico possible.

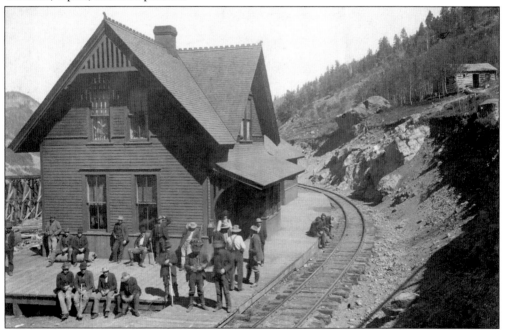

OPHIR DEPOT WITH OPHIR LOOP TRESTLE. In 1891, when Ophir's new depot was established west of the small town site, other businesses followed. Soon Ophir had a schoolhouse, hotel, and a popular fraternal order called the Improved Order of the Red Men.

Two

HARD ROCK, HIGH COUNTRY

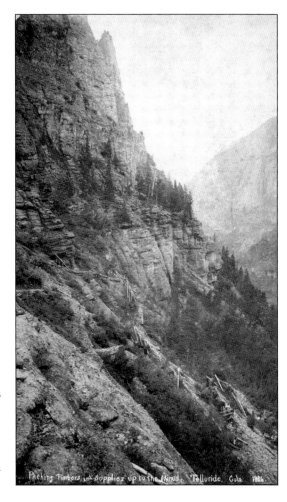

PACKING TIMBERS AND SUPPLIES TO THE MINES, 1886. Telluride's ravenous fortune seekers hastily carved heart-stopping roads out of sheer mountainsides to access mineral-rich veins radiating in the hard-rock peaks of the San Juan Mountains. Between the late 1800s and the 1930s, the mines around Telluride produced ore worth between $150 million and $200 million.

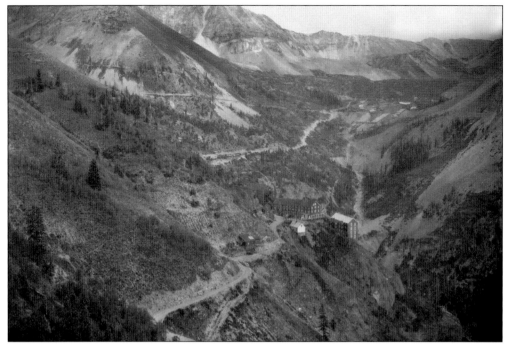

SCENIC VIEW OF THE SMUGGLER MINE, 1890. John Fallon's claims in Marshall Basin caught J. B. Ingram's attention when he detected a stretch of ground not properly claimed by Fallon. In keeping with the stealth nature of his claim, Ingram named this mine the Smuggler. A rich common vein, four to six feet wide, was shared by the Marshall Basin mines. It was eventually worked to a depth of 3,000 feet.

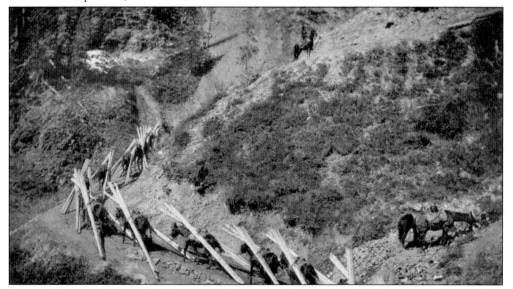

ON THE SMUGGLER TRAIL. Led by packers, long strings of mules supplied the mines with everything imaginable. When a burro fell off the terrifically dangerous roads, muleskinners kept the mule train going by literally pulling the fallen animal back into place. Prominent freighter French Alex Carriere (who came from Canada and met his wife, who worked in a Telluride boardinghouse) won a gold watch in 1900 as first prize in a packing contest.

SMUGGLER-UNION MINE. Productive mining was a capital-intensive proposition. Shanghai-based English and Scottish bankers and merchants began buying up Marshall Basin mines in 1883. Their holdings compounded, and within a few years, a vast labyrinth of mines was linked by the famous Sheridan Crosscut Tunnel that connected main and adjacent veins nearly 1,000 feet below ground. When the consortium sold out around 1900, the selling price of their holdings was $15 million.

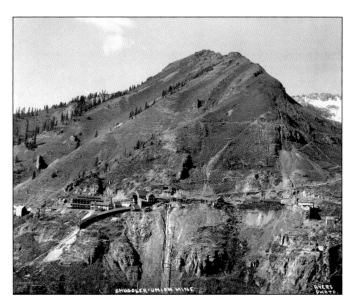

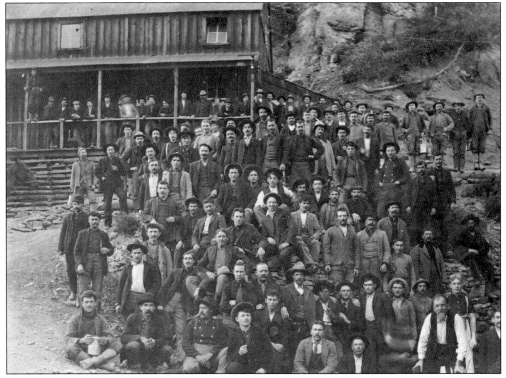

MINERS IN FRONT OF SMUGGLER-UNION BOARDINGHOUSE. Photographs of miners were used to attract the interest of buyers of stocks and bonds to finance the mines. Workers were largely immigrants from Italy, France, Austria, Finland, Sweden, Norway, Croatia, Greece, Cornwall, Scotland, and England. The term "hard-rock miners" refers to those who mined gold, silver, zinc, and copper as opposed to soft minerals like coal or uranium. Some Native Americans also worked as miners in the area.

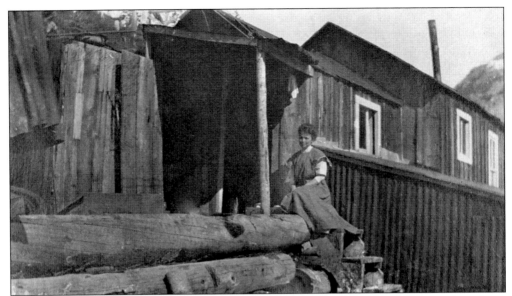

WOMAN OUTSIDE OF CABIN AT SMUGGLER, C. 1900. This unidentified woman may have been married to a miner or mine officer. Married couples at the mines lived in company housing. This primitive shack seems to have had the benefit of several additions. Single women were not allowed at the mines in Savage Basin during the late 19th and early 20th centuries.

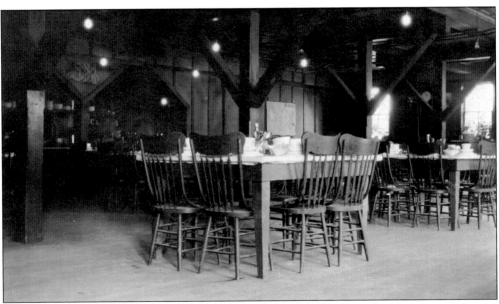

SMUGGLER DINING ROOM. Making sure miners were well fed was a means of retaining laborers. In this photograph, the Smuggler monogram can be seen on a timber by the kitchen. The well-appointed dining tables were in a brightly lit room. The dining staff was oftentimes men, and respectable women who came with a spouse were frequently employed as boardinghouse cooks.

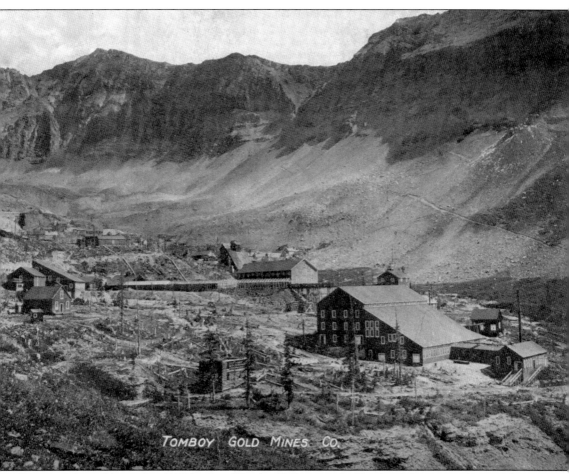

TOMBOY MINE. Claimed in 1886 by Otis "Tomboy" Thomas, the Tomboy Mine was rich in gold and silver. It reportedly fetched $2 million when purchased by Rothschild's of London in 1897. At 11,465 feet above sea level, the Tomboy complex featured a boardinghouse, school, tennis courts, and all of the latest in mining buildings. Eventually there was even a YMCA and bowling alley. Even so, life in the mining camps was never easy.

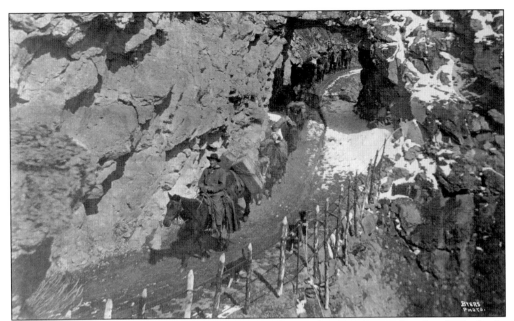

MULE TRAIN AT SOCIAL TUNNEL. From Telluride, the Tomboy Road, completed in 1901, climbs a swift but rugged 2,100 feet in the first three miles. After many seemingly impossible curves, it passes right through Social Tunnel, a portal blasted in rock where single women (who were considered bad luck at the mines) would rendezvous with their men. Approaching the Tomboy Mine in Savage Basin, the road rises a dizzying 600 feet in one mile.

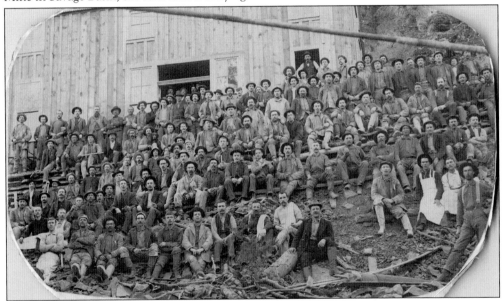

TOMBOY BOARDINGHOUSE BEFORE 1902. A changing house was used by miners who were expected to turn out for dinner dressed in a jacket. The Tomboy boardinghouse was known for its cleanliness. Located in Savage Basin, the Tomboy Camp feels absolutely at the top of the world. Ogda Matson Walter, a former resident at the Tomboy Mine, said the snow never just fell, instead it raged in a horizontal fury. Many miners of Scandinavian stock were adept skiers, and it was not uncommon for them to strap on wooden skis in order to move about the basin.

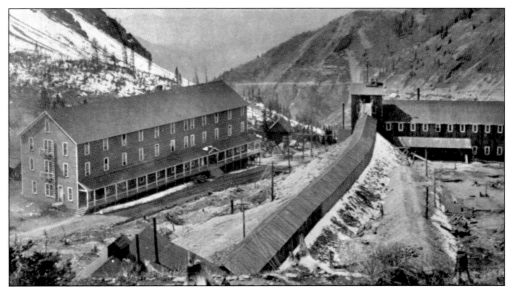

TOMBOY BOARDINGHOUSE. A porch ran the length of the Tomboy boardinghouse that served as home to hundreds of miners. Room and board was $1 a day. Sometimes a miner wound up indebted to the company for these and other charges. Snow sheds covered the tram tracks and walkways. In winter, snow tunnels connected buildings, and ropes were strung for people to follow to avoid getting lost in blizzards.

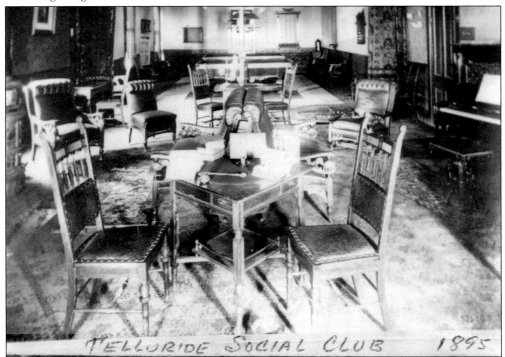

TELLURIDE SOCIAL CLUB IN TOMBOY BOARDINGHOUSE, 1895. This is believed to be the fashionable Telluride Club for married workers and their spouses, who were free to read, play cards, and enjoy playing a piano. At 11,465 feet, spartan company housing seemed especially small and grim in winter where snows begin in August and don't end until July.

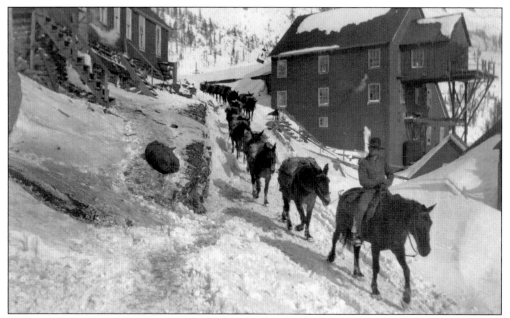

LOAD OF CONCENTRATES FROM TOMBOY MINE. Ores mined from the Telluride mining district made immense profits for mine owners and shareholders. The Tomboy Mine was particularly profitable. But sentiments between miners and mine owners had long been deteriorating; miners were poorly paid resulting in a lengthy series of strikes.

BULLION TRAIN LEAVING THE TOMBOY MINE. The weekly departure of mules laden with several thousand dollars of gold bullion is described with excitement by Harriet Fish Backus in her seminal work *The Tomboy Bride*. The Tomboy Mine had its own smelter where high-grade gold was separated from ore.

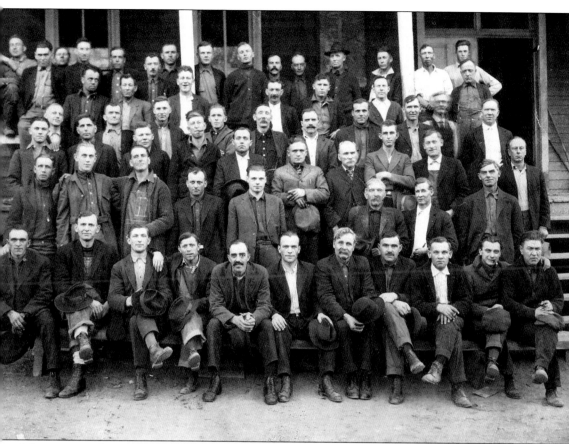

MINERS AND STAFF IN FRONT OF BOARDINGHOUSE. The Tomboy Mine boardinghouse was destroyed by fire on July 9, 1922, shortly after this photograph was taken, and was later replaced by a smaller one. In 1928, the Tomboy Mine closed permanently.

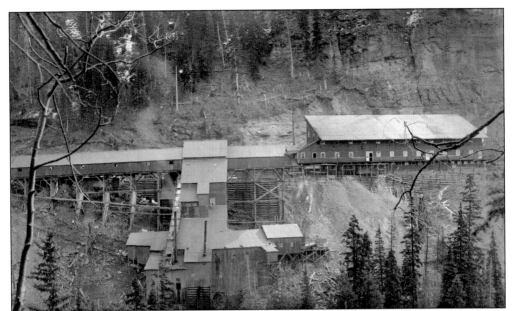

Lower Liberty Bell Mine, Still Well Tunnel and Boardinghouse. Discovered by W. L. Cornett in 1876, the Liberty Bell Mine was neglected in silver's heyday because it was thick with gold. After the repeal of the Sherman Act, gold-bearing ore made windfall profits for Liberty Bell's investors. Located below the crest of high peaks, it was victim to one of the most treacherous avalanches in Colorado history in 1902.

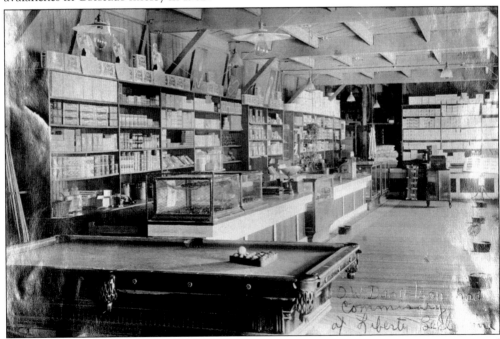

D. W. Danielson Commissary at Liberty Bell. A combination store, game room, and social parlor describes the quintessential company store. Miners bought Christmas presents, as well as their supplies, in mine commissaries, and children living in the camps gravitated to the commissaries for candy and ice cream.

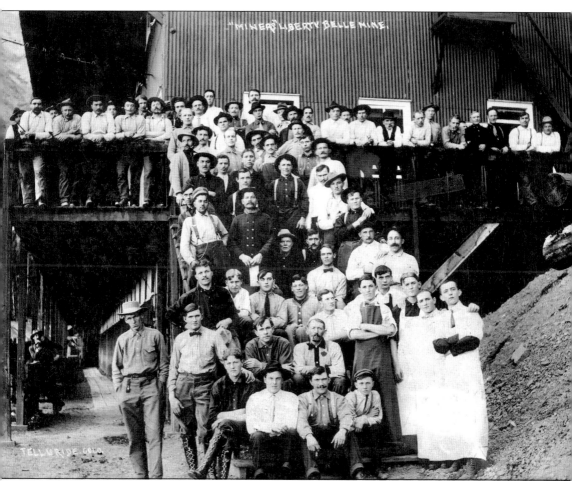

MINERS AT LOWER LIBERTY BELL, C. 1912. These miners and cooks (in white aprons) may not have slept well at night knowing that on February 28, 1902, a giant snow slide ran down Cornet Creek and careened into the Upper Liberty Bell Boardinghouse, smashing it into splinters. During rescue operations, another slide ran, killing two men. Then a third slide erupted and more men died. As evening fell, 19 men were dead and 10 injured. Later in the year, a bolt of lightening struck the ore tracks and electrocuted three workers deep within the mine.

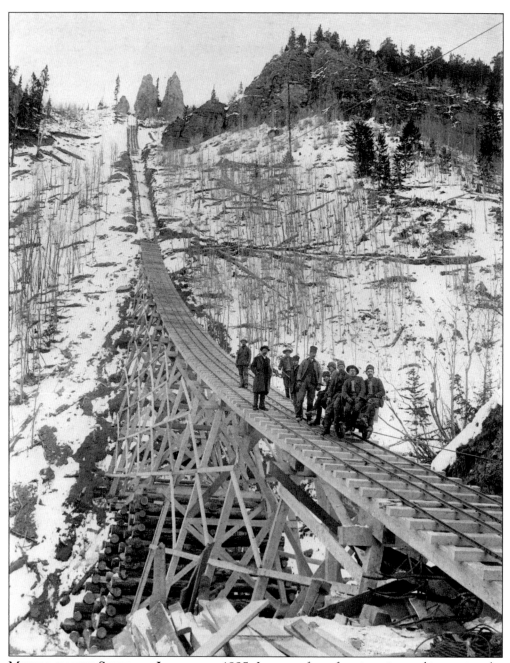

MINERS ON THE SHERIDAN INCLINE, C. 1895. In a true feat of engineering and ingenuity, the Shanghai investors funded an ore transportation system from the Sheridan Crosscut Tunnel, which was located on a ridge between Marshall and Liberty Bell Basins, down to Pandora. It consisted of underground tunnels 1,000 feet below the earth, a 230-foot-long suspension bridge, and this 6,900-foot-long funicular tramway that went to the mills at Pandora.

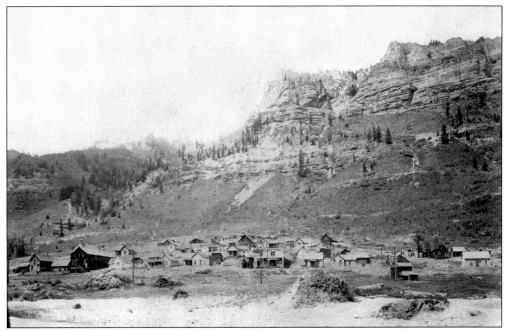

PANDORA VILLAGE. Pandora, at the east end of the Telluride valley, was settled in the early prospecting days and soon became the site of the Telluride valley mills. Gravity made its location in the Bridal Veil amphitheater a natural funnel for ore coming down from the surrounding mountains. In addition, the railroad was easily extended to Pandora, simplifying transportation.

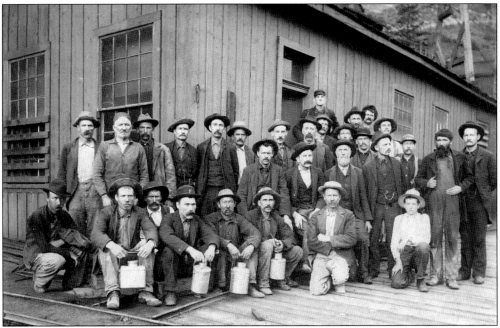

SMUGGLER AND UNION PANDORA MILL WORKERS, 1898. Miners, mill workers, and muleskinners considered themselves separate cultures, but they worked in an interdependent system. Smuggler-Union miners in the high country labored heavily for ore that was carefully packed by muleskinners for transport to the Pandora Mill where the ore was processed.

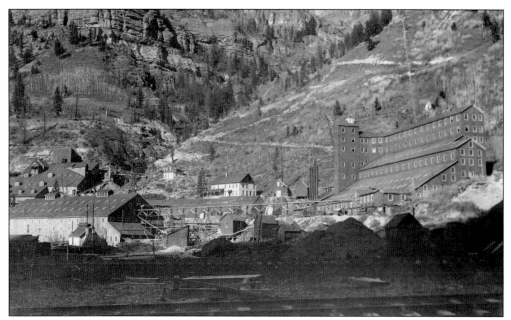

PANDORA SMUGGLER-UNION MILL. Long since destroyed, handsome metal mill buildings once climbed uphill. Large pieces of ore were delivered to the top level of the mill where a vertical network of machines noisily crushed and shook it into particles. By force of gravity, ore particles fell to lower and lower levels in the machinery for further crushing. Lastly the finely crushed ore was transferred into flotation cells where chemicals separated the metals from the waste rock.

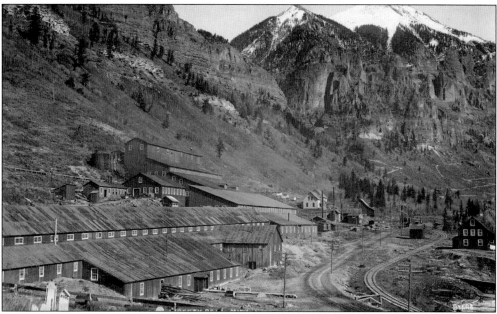

LIBERTY BELL MILL. A tramline was strung from the Liberty Bell Mine high above Telluride all the way to this mill, which was located beside Telluride's Lone Tree Cemetery. It closed in 1926 when damages awarded to another mining company in a trespassing suit could not be paid. The building quickly fell into disrepair. Its vestiges can be seen today just beyond the cemetery's east gate.

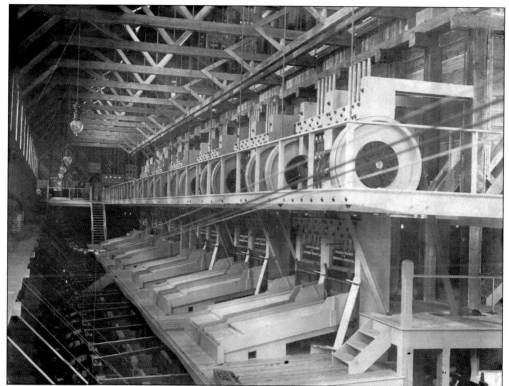

SIXTY-STAMP MILL, SMUGGLER-UNION AT PANDORA. Milling was a noisy process, especially with the advent of powerful stamp mills that literally stamped or pounded the ore into smaller particles. These were state-of-the-art facilities at the turn of the century, and for many years, the Telluride valley rang with this impressive sound.

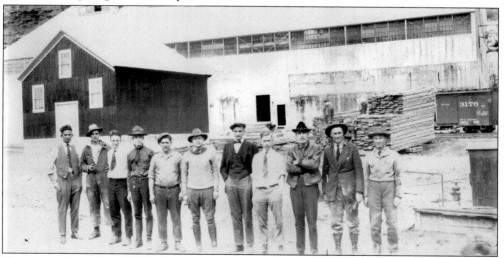

SMUGGLER-UNION MILL STAFF IN PANDORA. A disastrous fire broke out at the Smuggler-Union Mill on June 24, 1920, resulting in losses of about $200,000. The mill was rebuilt but would close in 1928 as mining waned in Telluride. Chapp Wood, at far right, was killed in the Camp Bird Mine avalanche near Ouray, Colorado, on February 25, 1936, where he worked as the mill superintendent.

TRAMWAY TO SMUGGLER MINE. Trams were a lifeline to and from the mines, carrying ore down and everything else up, including nails, food, boots, boilers, sinks, iron stoves, and adding machines. During the influenza epidemic of 1918, bodies from the mines were brought down in ore buckets. Once installed, trams took over the "heavy lifting" from muleskinners and their poor beasts. In the early 1900s, five separate tram terminals operated to and from the Smuggler-Union Mill in Pandora and some 54 trams were found in the Telluride mining district.

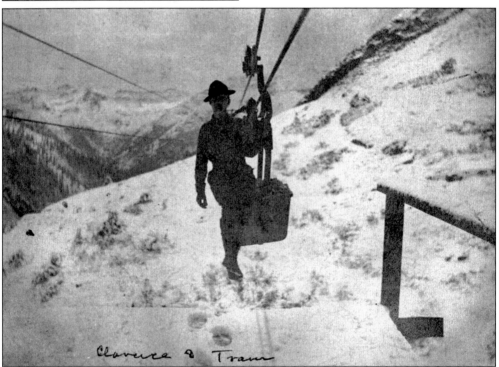

CLARENCE TODD ON SMUGGLER TRAM, 1905. The cable from the Smuggler-Union to Pandora traversed 3,000 vertical feet and was 6,700 feet in length. Even in the coldest of winter, people traveled to and from town by tram. Playful operators could start and stop the cables abruptly to rock their passengers. Local oral histories include many accounts of this daring, as well as moonlit, rides.

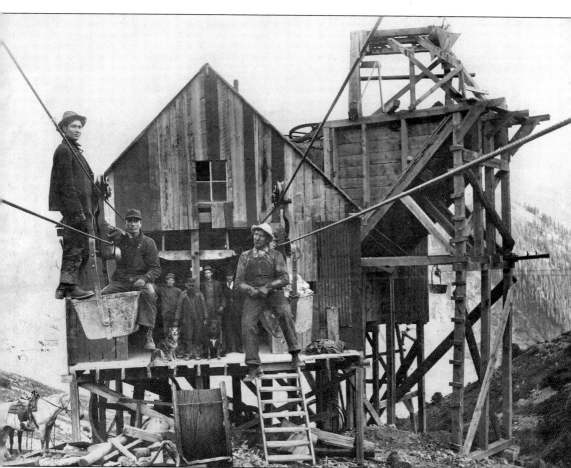

SMUGGLER-UNION MINERS IN TRAM BUCKET. Discarded tram buckets littered the high country for decades. Today they are highly prized mountain town yard decor. Spools and spools of abandoned cable drape the high country and traces of tram towers still exist. Today the tram's modern cousins, ski lifts and gondolas, continue to transport residents and visitors to and from the high country for recreation.

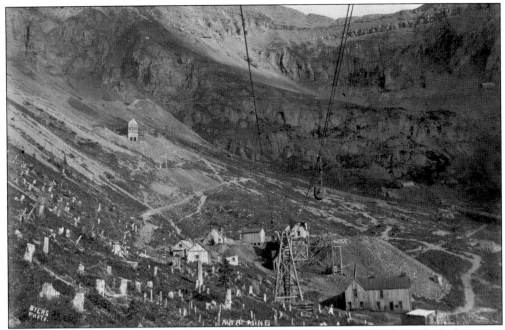

ALTA MINE AND TRAM LINE. Mountainsides were often left denuded and scorched when trees were cut for timber and fuel. The Alta Mine, south of Telluride and north of Ophir, was mined from 1878 until 1954 when the mill burned. The Alta Tram was built in 1910.

ALTA MINE BOARDINGHOUSE. The Alta Boardinghouse still stands, overlooking the once productive Alta Mine compound. A few residences also remain standing; in them one can find broken china and pieces of antique linoleum.

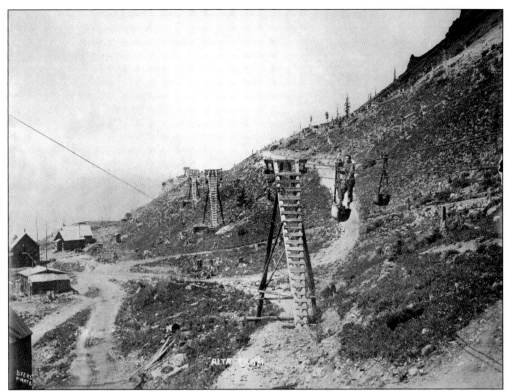

ALTA TRAM TOWERS WITH MAN IN BUCKET. The Alta Tram ran all the way to a building adjacent to the Ophir depot where ore would be deposited on Rio Grande Southern cars for transport to distant smelters.

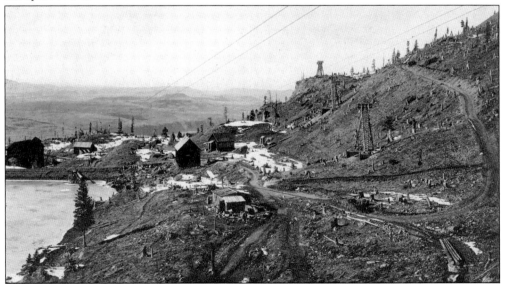

GOLD KING MILL AND ALTA TRAM. L. L. Nunn reduced fuel-operating costs at his Gold King Mine when he introduced alternating current (AC) electricity in 1891. He was the first in the world to use AC electricity for commercial purposes. Gold King was aptly named, as it produced volumes of high-quality gold ore from 1878 until its closure in 1954.

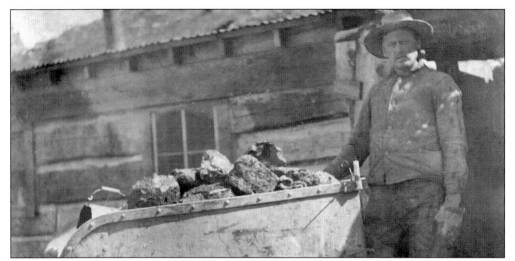

CECIL GREEN. This photograph shows Cecil Green emerging from the Smuggler Mine in 1895 with a fully loaded ore cart. Mining was dangerous and dirty work, and at an average of $3 a day, miners were not getting rich. The Telluride Western Federation of Miners Local 63 was chartered on August 3, 1896, as the Telluride Miner's Union and its members fought with mine owners for better pay and safer working conditions.

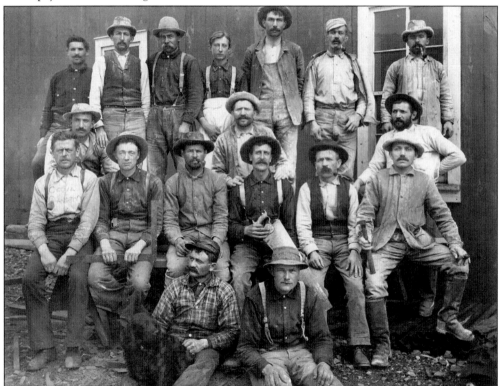

GROUP OF MINERS AT CIMARRON MINE. Miners rarely owned even a share of the mines they worked in and often bought their own tools, blasting powder, and clothes. Boarding fees, purchases from company stores, and low pay meant they frequently owed most of their wages to those for whom they worked.

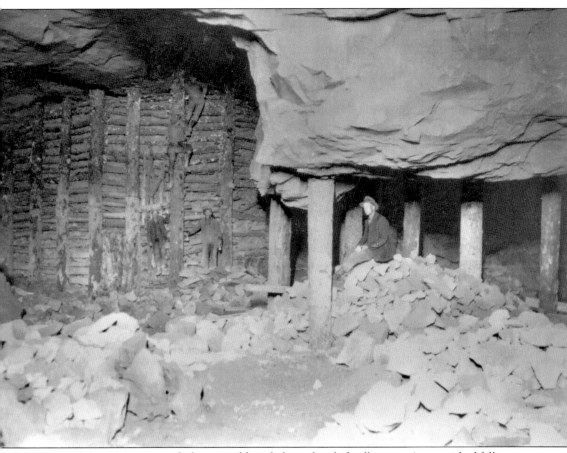

MEN INSIDE MINE. Mines were dark, wet, cold, and plagued with deadly gases. A man risked falling into deep shafts or being crushed by collapsing tunnels at every turn. For some, the payoff was adventure, for others a chance at a new life, but few enjoyed any significant gains in fortune.

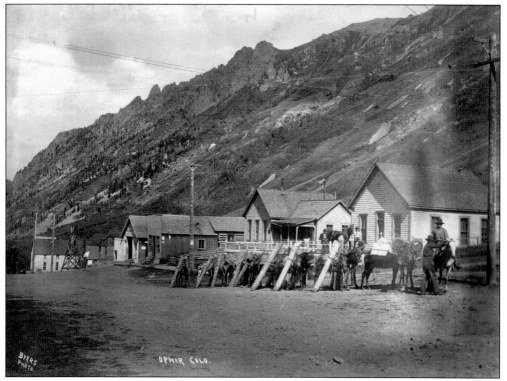

OPHIR, COLORADO. Ophir had a good run with mining, and its Silver Bell Mine was the longest running in the region, producing from its early days until the 1960s.

ORE SPECIMEN IN CART WITH MINERS IN FRONT OF BOARDINGHOUSE. Rico, a town south of Ophir and Lizard Head Pass, was also served by the Rio Grande Southern Railroad. Rico had several successful mines and like all mining towns, had a unique culture. In the 1920s, Rico and Telluride both had populations around 1,000 people. Today with the advent of the ski area, Telluride's population has far surpassed Rico's.

Three

BETH BATCHELLER
THE TOMBOY BRIDE'S FRIEND

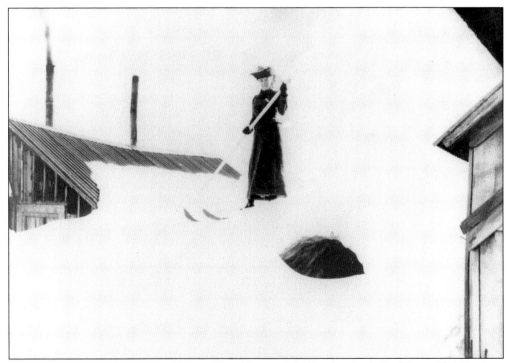

BETH BATCHELLER SKIING ON TOP OF HER HOUSE. *The Tomboy Bride,* by Harriet Fish Backus, is the definitive account of life at the Tomboy Mine between 1906 and 1910. Her best friend, Beth Batcheller, is pictured here on top of her house, just footsteps from the Backus cabin. Carrying a blanket-wrapped baby in her arms, it was Beth who knocked on Harriet's door welcoming her to her new home. Together they shared the challenges of living in a mining camp at 11,500 feet above sea level.

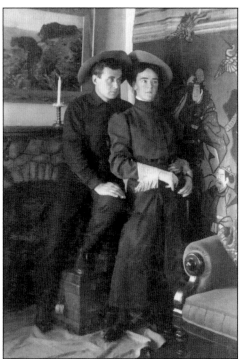

WEDDING DAY. In 1905, Elizabeth Towne Field and J. H. Batcheller, both of New England aristocratic stock, had a "society" wedding in Mattapoisett, Massachusetts. Jim was a graduate of the Massachusetts Institute of Technology and was superintendent of the Tomboy Mine. Harriet described Beth as a beautiful, olive-skinned woman with lively eyes. However her son Billy was frail, and Beth was in constant communication with Dr. Hadley in Telluride, who had attended his birth at the mine. Later Harriet Backus would deliver the first baby born in Telluride's Miner's Hospital, which today houses the Telluride Historical Museum.

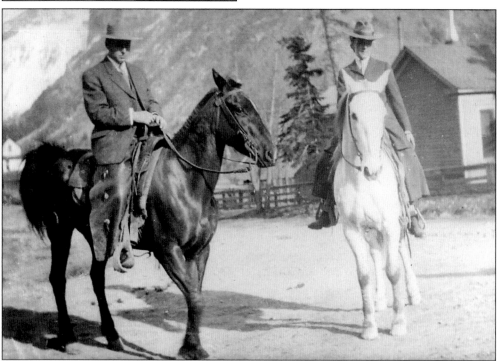

A DAY IN TOWN. Beth and James Batcheller, pictured here, are turned out in smart riding wear. The safest passage to and from the mines was on horseback; the Tomboy road was made dangerous by freighter traffic, and carriages were known to fall off the road on occasion. Because culture dictated smart clothing, milliners and haberdashers were commonplace in Telluride.

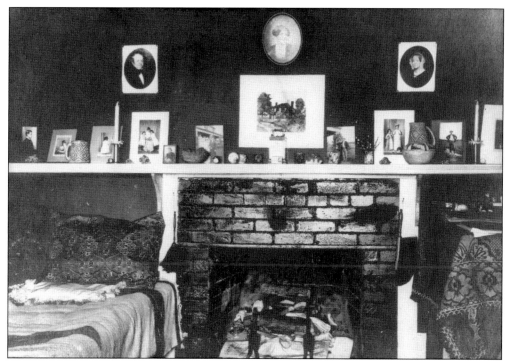

FIREPLACE AT CASTLE SKY HIGH. Married workers lived in sparse, uninsulated, 220-square-foot board-and-batten structures. The Batcheller's christened theirs "Castle Sky High." Backus's account notes it was scented with rose potpourri and its mantle piece held pictures of relatives from back east and gleaming candlesticks. Beth enjoyed using her fine silver tea service and china to entertain.

BETH, BILLY, AND DOG JACK. Beth's Aunt Fanny came to visit one summer, dubbing the country around them the "America's Swiss Alps." Like her aunt, Beth was well traveled and sophisticated. Woods Lake, where the Batcheller's stayed in the Wheeler family cabin, is below Telluride and a popular getaway, both then and now. Being out of the high country was good for fragile Billy Batcheller.

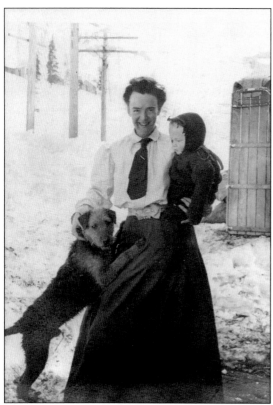

"Mommy, I'm So Tired." Beth and Billy, seen here with Jack, were just home from a winter respite in Massachusetts when Billy began failing. A doctor was summoned from Denver on a train that flew white flags so it could be waved through on the 24-hour emergency trip. It took him no time to make the diagnosis: spinal meningitis. Little Billy slipped away, and soon thereafter, the Batcheller's left Castle Sky High.

Tomboy. The Tomboy mining camp was at the top of the world. No one has said life there was easy, but records reveal more humor than complaint.

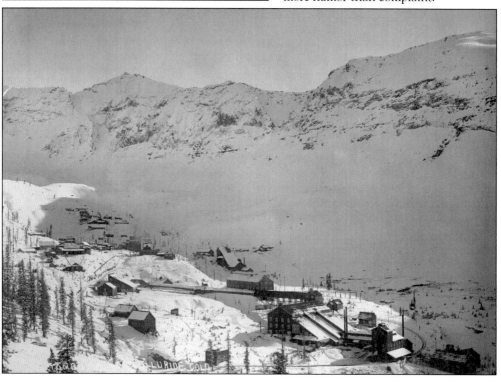

Four

THE TOWN WITHOUT
A BELLYACHE

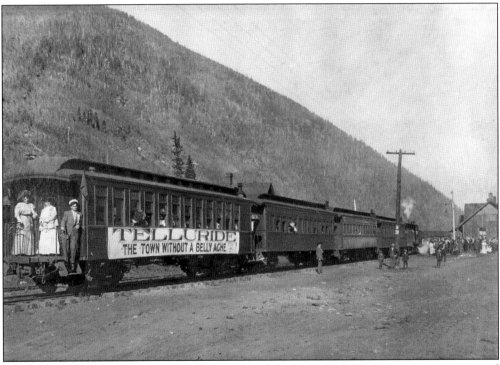

TELLURIDE: THE TOWN WITHOUT A BELLYACHE. It has been said that a passenger once arrived at the Rio Grande Southern Depot in Telluride only to gasp in wonder and trepidation. Spying this, a wry conductor crowed, "This is it. To Hell You Ride." The train banner in this image, "The Town Without A Belly Ache" refers to the indomitable, can-do attitude exhibited by Telluride's hearty residents, rugged individualists all, known for tenacity, ingenuity, and a keen sense of humor in good times and in bad. Here baseball fans are on the way to Ouray on a chartered train to root for their team, c. 1900. Visiting Telluride can take determination, even with modern transportation. In 1924, when Barnum and Bailey came to town, it was feared that the animal-heavy train cars would not be able to navigate the narrow-gauge railway up Keystone Hill. Undeterred trainers and big top workers walked the elephants uphill, and mule-drawn carts delivered the lions, tigers, and bears.

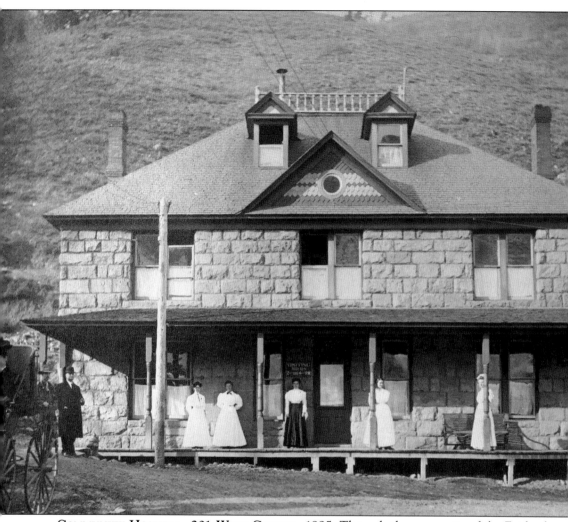

COMMUNITY HOSPITAL, 201 WEST GALENA, 1895. Through the generosity of the Fairlamb family and the local American Legion post, the Town of Telluride was able to acquire the historic hospital building at the top of North Fir Street for use as a museum. Established in 1965 as the San Miguel County Historical Society, the museum has operated for more than 40 years within this 1896 historic landmark building. The museum serves as a cultural and historical anchor for the town, providing a sense of community in the face of growth and change. Originally built by Dr. Harry C. Hall and funded by the mines and community business leaders, the hospital has undergone many transformations over the years from its origins as the Community Hospital. It has also been known as the American Legion Hospital and the Old Miner's Hospital. In this image, Dr. Anna "Frances" S. Brown is on the porch with nurses. She kept an office in the First National Bank building on Colorado Avenue and served as the public health officer during the deadly influenza epidemic of 1918 and 1919.

Dr. Edgar Hadley in Front of Hospital. When *Tomboy Bride* author Harriet Fish Backus lived at the Tomboy Mine, Dr. Edgar Hadley cared for many injured and sick miners at the hospital. The "miner's con," or silicosis, accounted for countless miners' deaths. In the early 1900s, visiting the doctor cost only $1 and home visits ran anywhere from $2 to $5 dollars. This was quite a pill to swallow when mine workers typically made only $3 a day and paid $1 a day for room and board.

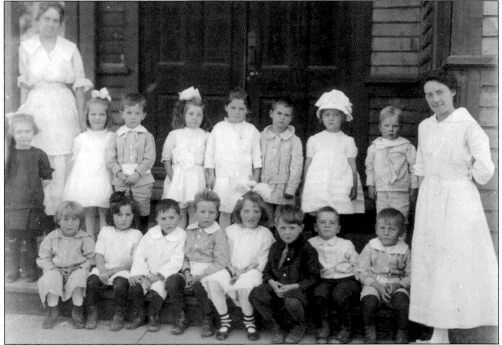

Kindergarten, 1918–1919, the Year of Deadly Influenza. Epidemics were common in early Telluride. Pneumonia was a constant threat and Dr. Anna "Frances" Brown was known to specialize in its treatment. During the infamous flu outbreak from October through December of 1918, 10 percent of Telluride residents succumbed to this deadly disease. The Roma Hotel had 60 beds for stricken mine and mill workers, and bodies were carted out of the mountains in tram buckets. The able-bodied were enlisted to help nurses, public gatherings were banned, and a quarantine was enforced. The schools closed for several months, and once reopened, Saturday classes were held to make up for missed time.

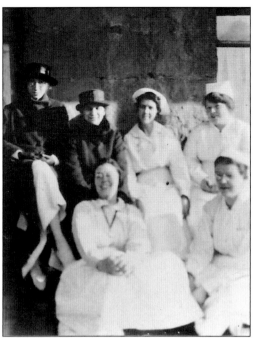

NURSING STAFF ON PORCH AT TELLURIDE HOSPITAL. Small pox was seen in 1884, scarlet fever ran rampant in 1896, and both scarlet fever and diphtheria raged through Telluride during 1904 and 1905 and again in 1916. A "pest house" was maintained west of town on a sunny south-facing hillside. Like the "poor house" in the same vicinity, it was fully staffed. Adults and children recovering from contagious illnesses were sent to the pest house without their family members to prevent further spread of disease.

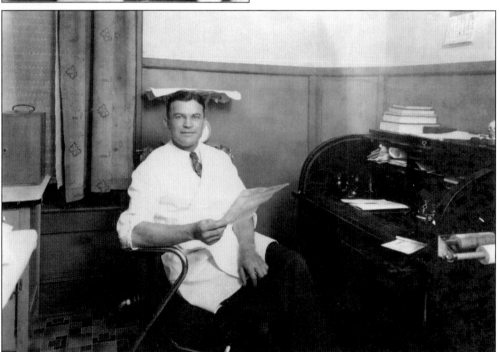

DR. JOE PARKER IN HOME OFFICE, 1935. A recent graduate of the University of Colorado, Dr. Joseph Parker came to Telluride in 1932 and stayed until 1947 when he relocated to Grand Junction. He faithfully served the region and drove miles and miles to see his patients. Dr. Parker is pictured here in his home office on Colorado Avenue where he held appointments for a short period of time when the hospital was closed in the early 1930s for financial reasons. His wife served as his office nurse.

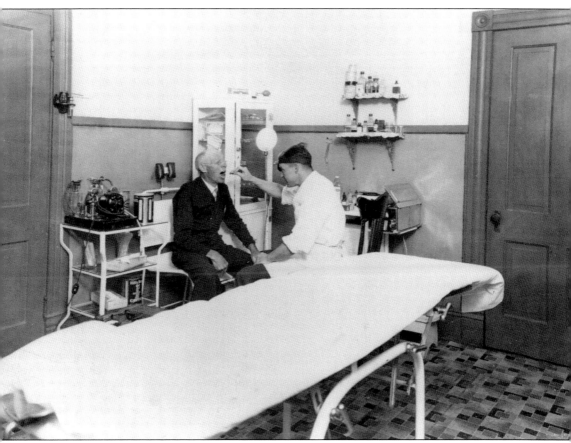

DR. PARKER EXAMINING DAN HANLON. It was Dr. Parker's responsibility to care for the sick and inspect the site of mining accidents where death was not uncommon. He was known not only as an esteemed physician but as an exceptionally compassionate individual, who served as Telluride mayor, school board president, county coroner, fireman, and even deputy sheriff. Telluride miners winched a Popcorn Alley crib from its foundation in town and hauled it to Trout Lake so the doctor had a place to stay during trips to and from Rico. The Parker family still maintains the cabin as a family vacation home.

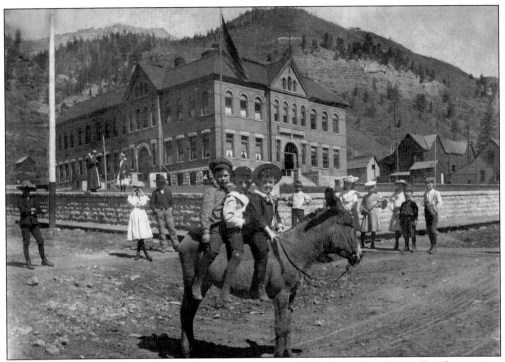

TELLURIDE SCHOOL WITH THREE BOYS ON A BURRO. The first school in Telluride was in a private home on North Spruce Street in 1881. In 1883, the building known as Rebekah Hall on Columbia Avenue at Fir Street was built as a schoolhouse. The old school bell remains on Rebekah Hall today as does a tower built for hanging wet fire hoses by the Telluride Fire Department when it took over the building in the 1880s. As Telluride's population swelled, this fine three-story brick school was built in 1896 for $24,000 on Columbia Avenue at Townsend Street. Today the building houses the Telluride Elementary School.

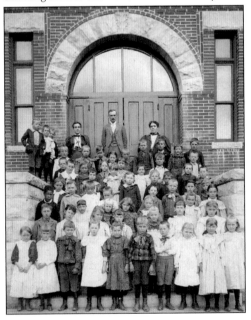

TELLURIDE SCHOOL, 1897. Teachers were paid roughly $60 a month in 1897. Early Telluride was a multilingual town because immigrants from around the globe had come seeking a new life. Consequently many of the school children did not speak English. However as the students learned English, the language was taken home, acquainting parents and younger siblings with it.

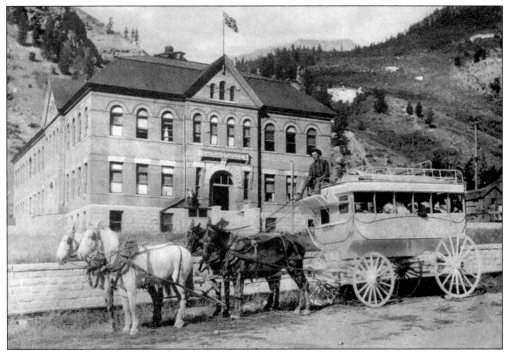

TELLURIDE'S FOUR-LEGGED SCHOOL BUS, C. 1912. This carriage brought children to and from school. In winter, a sleigh would replace the bus. The Telluride School had an electrified kitchen due to the ingenuity of a neighbor right up the street, L. L. Nunn, who introduced alternating current (AC) electricity to Telluride, to the nation, and to the world (see chapter six).

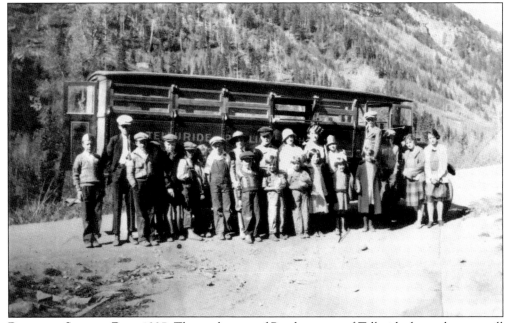

PANDORA SCHOOL BUS, 1927. The settlement of Pandora, east of Telluride, housed many mill workers and mining families. Students living with their families on the east side of town required transportation to make the trip to school each day.

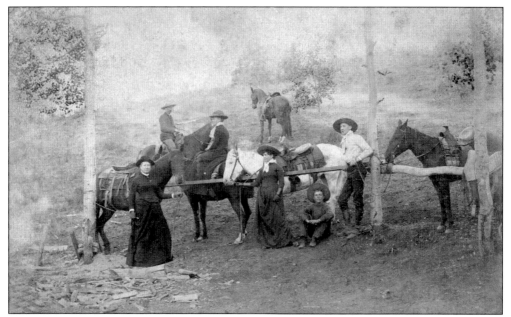

Mrs. John Walton, 1880s. The Waltons appear in the 1885 census for San Miguel County. They made their fortune in silver and subsequently lost their fortune when the Sherman Silver Purchase Act was repealed in 1893. Mrs. Walton appears at far left.

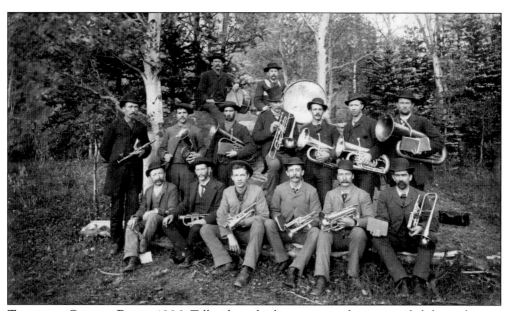

Telluride Cornet Band, 1886. Telluride and other towns in the state prided themselves on bands that often traveled to competitions throughout the state of Colorado.

CHAIR ROCK. This photograph is from the Charles Painter collection. He was a businessman and publisher of *The Journal*, Telluride's first newspaper. Painter also served as mayor of Telluride and the first San Miguel county clerk. Accompanying Charles Painter to Chair Rock, from left to right, are James P. Redick, Mrs. Redick, George Rohwer (seated), Mabel Redick Thomas, Mrs. Rohwer, Charles F. Painter (seated), and Mrs. Painter (standing). Chair Rock is behind the Telluride Middle/High School. Seniors show their school spirit with an annual painting of the rock.

SAN MIGUEL EXAMINER **PRINTING OFFICE, C. 1893.** In addition to *The Journal, The San Miguel Examiner* was published between 1897 and 1929. The home of the newspaper still stands on Colorado Avenue in what is still called the Examiner Building. Both papers were known to espouse the sentiments of their publishers as opposed to being unbiased chronicles of the times. The building to the left once housed the Metropole Skating rink.

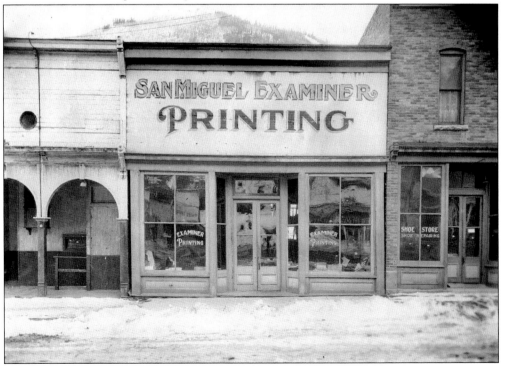

VAN ATTA FAMILY AT HOME. One of Telluride's early-day merchants, Welland Buxom Van Atta, became wealthy as an outfitter. The merchant's home was filled with books and fine furnishings.

VAN ATTA HOME AT 123 ASPEN STREET. The Van Atta home still stands on the sunny side of town. The Van Atta's daughter Eleanor became a medical doctor and had an office in the First National Bank Building by 1890. Story has it that the Van Atta family was once stuck in a blizzard outside of town and was rescued by one of Dave Wood's freight teams.

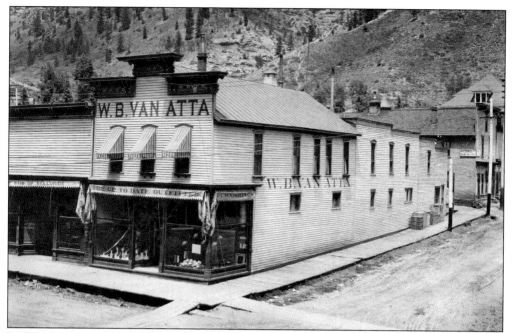

W. B. Van Atta Store, Northwest Corner of Pine Street and Colorado Avenue.
The Van Atta Store, named for its owner, opened in 1883 claiming the title, "The Up-to-Date-Outfitter." The store had everything miners and residents in town needed and more. Tall, revolving racks of exotic colorful ribbon, bolt fabrics in taffeta, satin, floral, and plaid, and laces and trims were stocked. In the early 1900s, it was as if all the finery of Paris and New York had arrived in the remote mountain town of Telluride. Families would dress in their Sunday best for Saturday night shopping excursions.

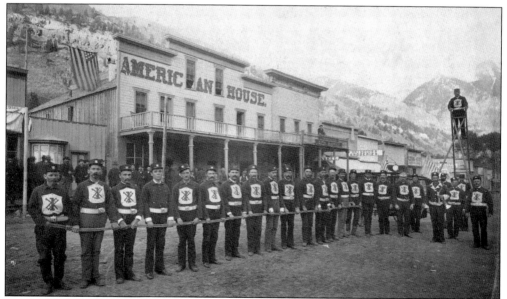

Telluride Fire Department, Late 1880s. Peers referred to Van Atta as a gentleman of the old school. Seventh from the left, Van Atta served with the Telluride Fire Department, pictured here before the American House Hotel.

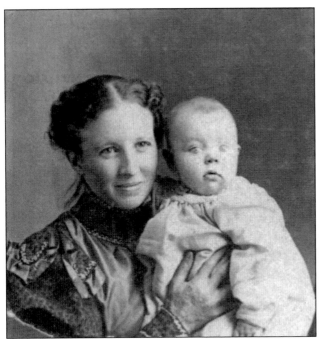

CARRIE ROGERS, WIFE OF J. W. ROGERS. The arrival of respectable women and growing families were one of the first signs of Telluride's transformation from a mining camp to a stable, urban community.

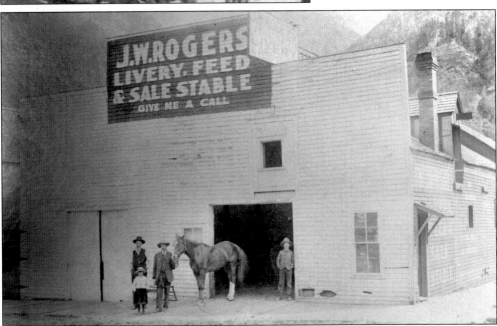

J. W. ROGERS LIVERY, FEED, AND SALE STABLE. J. W. Rogers is pictured here with his son Melvin. In the early 1900s, Rogers Livery was one of three important liveries in Telluride. Harriet Fish Backus mentions the Rogers Livery many times in *Tomboy Bride*. The streets of Telluride were constantly alive with the sound of horse hooves as men moved to and from town and the mines. Saddled mounts were trained to walk to the mines for riders who had hired their services. Both horses and mules knew their routes well and dashed back to the livery stables when released from their duties. Mothers literally feared for their children when these mounts came rushing through town.

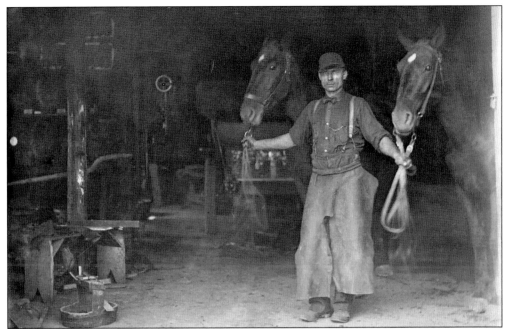

JOHN KEITH, BLACKSMITH. A veteran of the Spanish-American War and a native of Pennsylvania, Keith lived in Telluride from 1905 until 1949. His blacksmith shop was located on the southwest corner of Colorado Avenue at Willow Street. A good blacksmith could earn a decent living; in the early 1900s, their services were vital.

TELLURIDE TRANSFER. This handsome large rock structure stands empty and roofless today at the southwest corner of Pacific Avenue at Fir Street. In the 1940s, the Telluride Transfer letterhead listed the following: Garage, fuel, merchandise, trucking, motorola [sic], Radios—Spartan—Dodge-Norge-Plymouth. In the late 1880s, the Transfer supplied horses to the miners, the school carriage, and the stage to the Marshall Basin mines. Later its inventory of motorized vehicles hauled coal, freight, and mail.

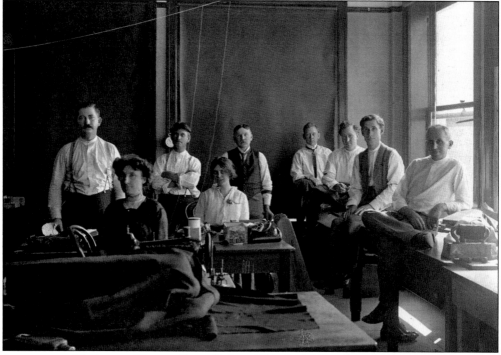

INTERIOR OF MCINTOSH TAILOR SHOP. Before 1893, the McIntosh Tailor Shop was located on West Colorado Avenue. Ready-wear clothing did not exist. Patterns and precut fabric could be ordered from catalogs, and tailors were in great demand to piece together clothing. Suits, vests, flaring skirts, and lacy shirts with puffed sleeves were the order of the day. Many women were accomplished seamstresses, and it was not unusual for children to wear homemade clothing.

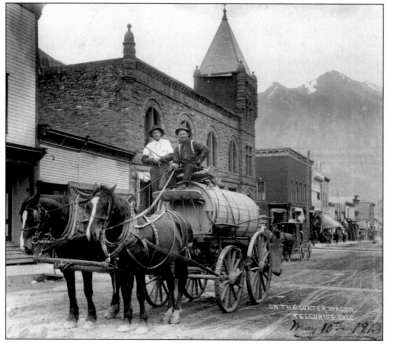

ON THE WATER WAGON, MAY 10, 1913. The driver of this water wagon, George Van Eugene, was a Telluride marshall and fought in World War I. In Mary Alma Midwinter's fascinating account of life in Telluride during this era, water was supplied to town businesses as pictured here.

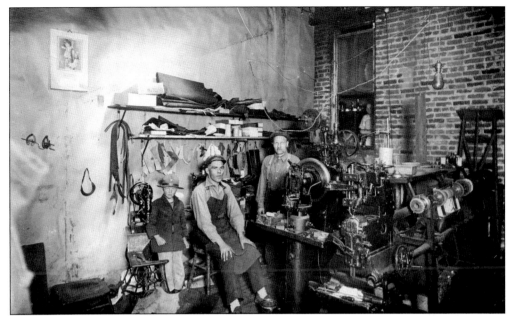

PEKKARINE'S BOOT SHOP. Finnish immigrants, the Pekkarine's, settled in Telluride around 1900. Aaro was an excellent boot maker who made wooden lasts for his customers. His cowboy boots drew customers from as far away as Montrose. On the back of the photograph, Dr. James Parker, son of Dr. Joe Parker, wrote on July 19, 2002, the words "1906?" and "They used to keep a vat of banana oil. It always smelled so good. They used to dip the shoes in the oil to soften the leather."

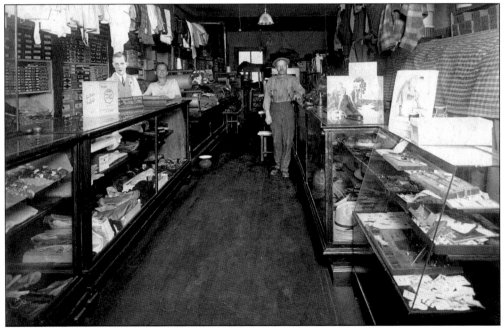

MR. AND MRS. PEKKARINE IN THE PEKKARINE STORE, 1926. Mr. and Mrs. Pekkarine stand among long cases of merchandise. A sign on the counter reads, "Look Better, Wear Longer, Wear Friers Shoes." The family lived on the third floor, the store was on street level, and the boot shop was in the basement of the Pekkarine Building.

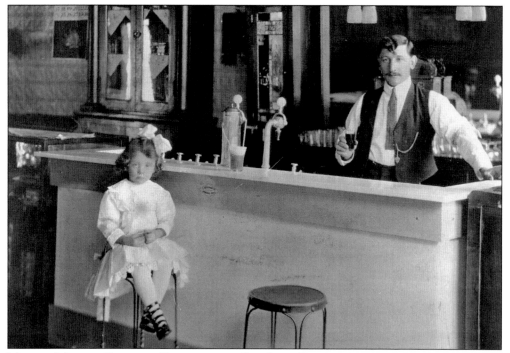

MARINA MATTRI CLEMENTI PATTERSON IN SAN JUAN BUILDING, C. 1920. Marina is pictured with her father in the old San Juan building on Colorado Avenue where he owned a soda fountain with Paul Nardin. Her father changed his Italian name from Nicolo Mattarei to Nick Mattri. Her parents met when her mother, Albina Deromedi Mattarei Clementi, was a cook at the Sheridan Crosscut Mine. Marina was born in 1915 at the Smuggler Mine and worked for Dr. Joe Parker as a surgical nurse in adulthood. Traditionally Italian families lived on or near Catholic Hill in East Telluride.

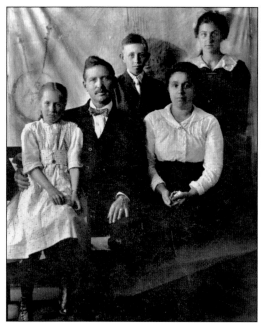

PAUL AND DOMINICA DALPEZ NARDIN AND FAMILY. The Nardins and Mattis lived and worked in the old San Juan building. Pictured here, from left to right, are Ester, Paul, William, Dominica Dalpez (the mother, seated), and Emma Nardin. Food and drink were served at the soda fountain, which had a marble counter, wrought iron tables, and a beautiful player piano. There were 12 rooms upstairs, and the building was one of the few in town with radiator heat.

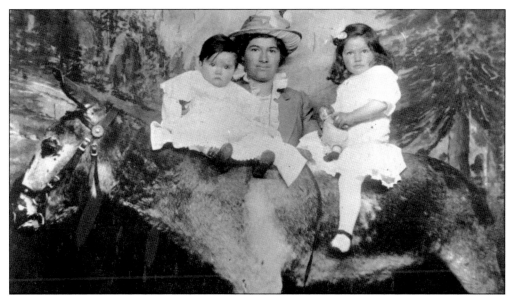

IRENE VISINTIN AND ELVIRA VISINTIN WUNDERLICH. "The Sisters" were Telluride's doyennes for nearly a century. Irene was born on April 25, 1907. Elvira was born July 4, 1914, and passed away in 2006. In this photograph, they are with their mother, Ermida Canestrini, who was widowed in Telluride before marrying their father, Emanuele Visintin. Both parents were Austrian immigrants. In the flood of 1914, Visintin rushed home to Oak Street from his Telluride Beer Hall business and Mrs. Visintin passed Elvira through a window to safety. His business partner, Oscar Wunderlich, was out of town and lost a grand new home on Oak Street and all of the family's possessions. Later the Wunderlich's became Elvira's in-laws.

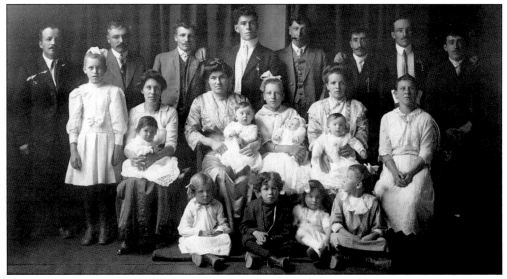

DEROMEDI, VISINTIN, AND MATTRI FAMILIES, JULY 1915. Pictured here, from left to right, are (first row) Eva Deromedi, Albert Deromedi, Irene Visintin, and Alma Deromedi; (second row) Elvira Visintin, Etta Deromedi, Marina Mattri, and Anna Deromedi; (third row) Lena Deromedi, Serafina Deromedi, Ermida Visintin, Katherine Deromedi, Albina Mattri, and Mary Deromedi; (fourth row) and John Deromedi, Emanuele Visintin, Joe Deromedi, Nick Mattri, Ricardo Leonardi, unidentified, Gust Deromedi, and Julio Leonardi.

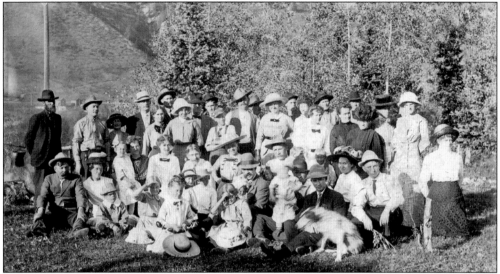

SWEDE PICNIC, JULY 30, 1913. A dirt road crossed the flats at the foot of the mountain near Bear Creek. Cleared by Swede-Finns, it was called the Swede-Finn Picnic Grounds, but the area was open to all. Swede-Finns hailed from Finland near the Swedish border and spoke Swedish but considered themselves Swede-Finns, not Swedes and not Finns.

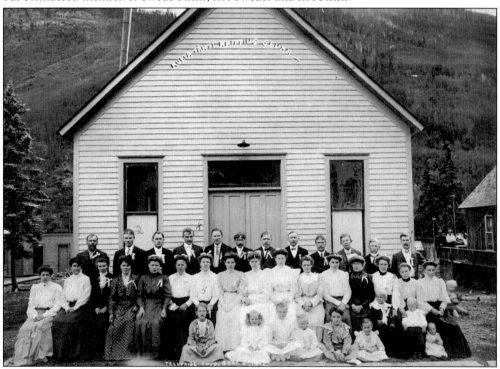

FINN HALL WITH GROUP IN FRONT. By 1900, more than 100 natives of Finland called Telluride home. A tight-knit community, they and a large number of Swedes and Swede-Finns lived on West Pacific Street. Each group had its own community hall where dances, weddings, and funerals took place. The buildings were constructed by hand using volunteer labor. A Finnish minister spent summers in Telluride and held Lutheran services in Finn Hall, built in 1886.

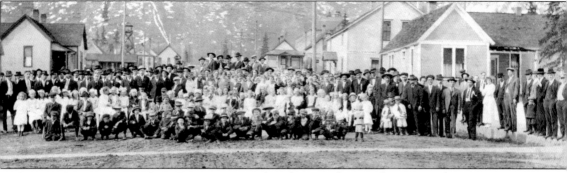

FINNISH INDEPENDENCE DAY, MAY 1, 1916. This photograph was taken on Pacific Avenue at Townsend Street. Finn Hall, now a private residence, and Swede-Finn Hall, now the Elks Club, still stand in the 400 block of Pacific Avenue. West Pacific Street was also home to a thriving Finnish sauna business. Residents on the west end of town housed animals in rear-yard sheds and barns; many are designated historic landmarks today.

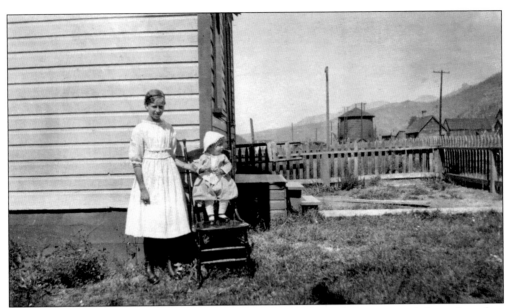

VERNICE ASNERMAN AND BETTY CARLSON, C. 1920. Scores of women married to miners lost their spouses to illness and accidents. Along West Pacific Street, many of the widows opened rooming houses where boarders were fed and housed. To raise additional income, they took in literally tons of laundry that was washed by hand. Children of these widows sometimes gathered coal cinders from the rail tracks to burn for fuel at home. Note the Rio Grande Southern Railroad water tank in this photograph of two young girls in their yard.

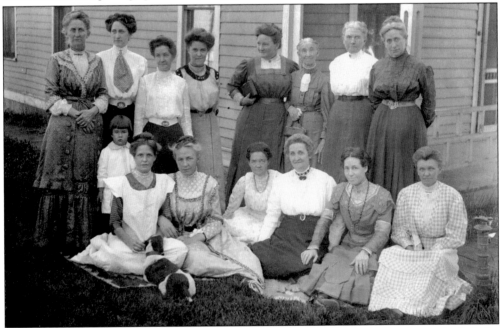

GROUP OF WOMEN IN FRONT OF HOUSE. Life was not easy for most in Telluride, particularly for women and single mothers. These unidentified women's stories are unknown but must include their journeys to town, their hardships in this harsh environment with few amenities, and their family lives—both happy and sad.

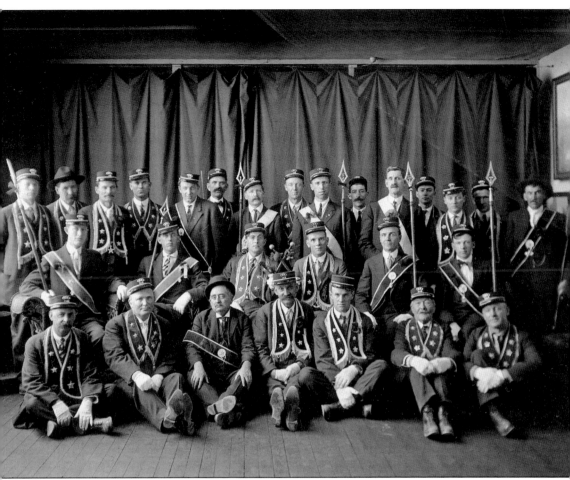

ODD FELLOWS LODGE, C. 1920. In 1897, 11 distinct benevolent societies appeared in the organizational meetings column of *The Telluride Daily Journal.* By 1905, there were 20 men and women's clubs benefiting the community. Membership sometimes included burial insurance and assistance for widows and children. Clubs were a source of belonging, entertainment, prestige, and political unity.

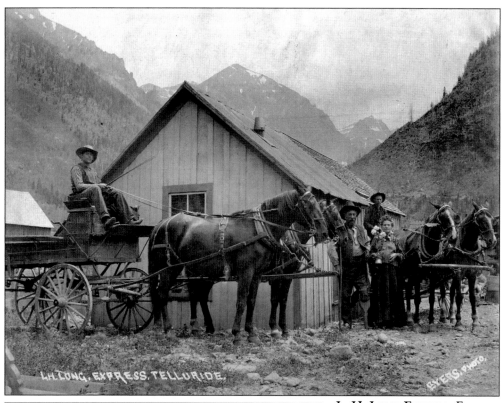

L. H. LONG EXPRESS. For a number of years, Lou Long's Express transported freight and mail. Lou is seen here with his parents.

LOU LONG. Lou Long's brother Lee, a former muleskinner, painstakingly trained the Telluride Fire Department's water-wagon horses, Beachy and Barney. On June 24, 1920, the night of the infamous fire that destroyed the Smuggler Mill, a panicked volunteer fireman unfamiliar with the hose cart hitched the team to the wagon improperly. Lee realized the mistake as the team tore through town, reins flying loose, but it was to no avail. He refused to abandon his team and was sent to his death under the wheels of the crashed wagon trying to get the horses under control.

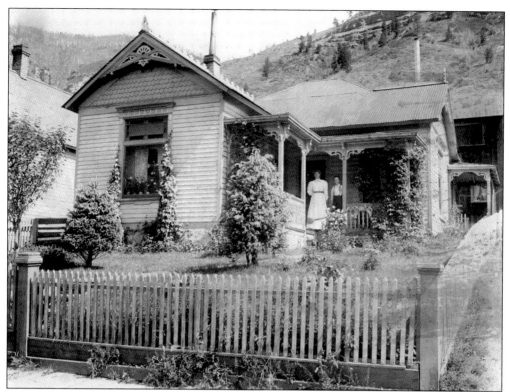

BALLIGER HOME IN EAST TELLURIDE. Balliger, a carpenter, made much of the Victorian gingerbread trim used on historic Telluride homes. His two-story workshop still stands behind this home in the 300 block of East Columbia.

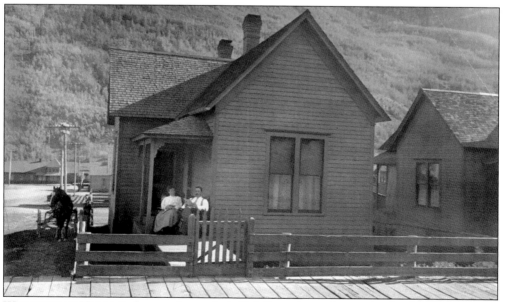

WUNDERLICH HOME. Before moving to their Oak Street home, lost in the flood of 1914, Hedwig and Oscar Wunderlich lived on the southwest corner of Colorado Avenue and Townsend Street. Oscar operated the Telluride Beer Hall with Emanuele Visintin.

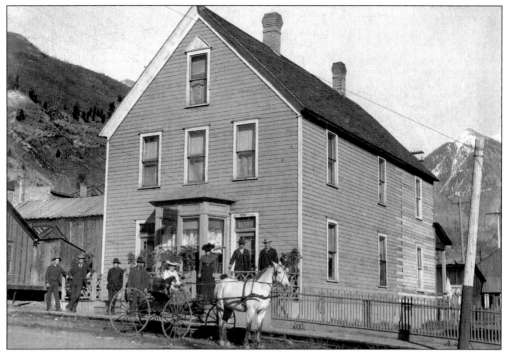

DAHL HOUSE WITH CARRIAGE IN FRONT. Telluride was a highly transient place in the 1890s, and this was one of many boardinghouses that catered to miners. Still called the Dahl House, it was built in the 1890s and is found on Oak Street between Colorado Avenue and Pacific Street.

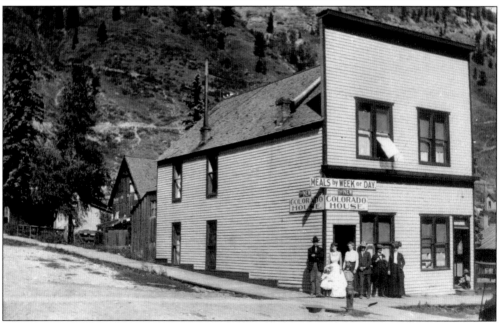

NEW COLORADO HOUSE AT NORTH PINE STREET AND COLUMBIA AVENUE. This building once stood across the street from the Miner's Union. This same troupe of actors can be seen in the photograph on page 87. The popular New Colorado House was later renamed Iowa House and can be seen after the flood of 1914 on page 103.

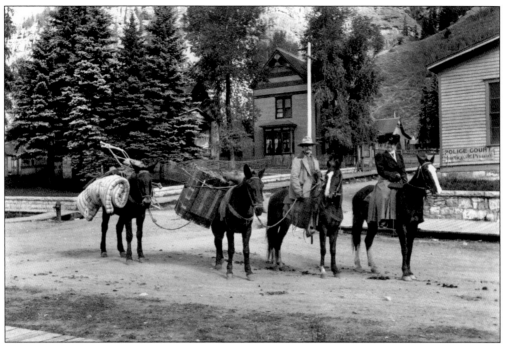

MOVING DAY IN TELLURIDE. Mr. and Mrs. Mathew Thomas, on their way to live at the Tomboy Mine, take a few things to brighten their spartan 200-square-foot cabin provided to married workers by the mine company.

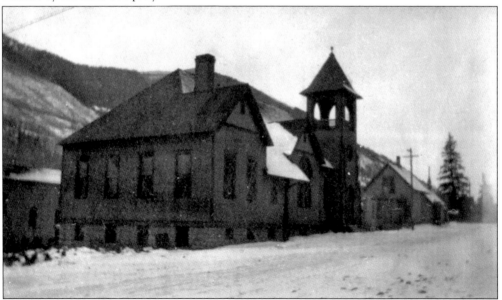

METHODIST CHURCH. For many years, Telluride had no church. The first was located in the 400 block of West Columbia and later became Christ Presbyterian Church. In 1915, the school board purchased this Methodist church to use as the high-school recreation building for basketball games, dances, plays, and community activities. Wire screening protected its stained-glass windows. On the southeast corner of Oak Street at Columbia Avenue, the Methodist church was known for many years as the Oak Street Inn and has subsequently been converted into a private residence.

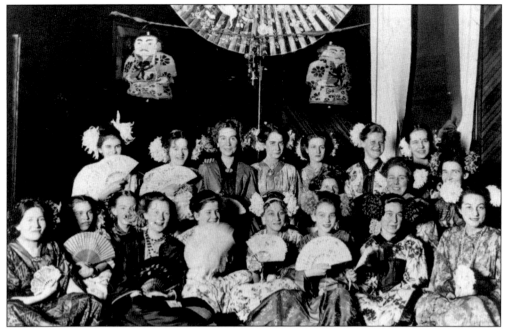

JAPANESE SOCIAL GIVEN BY Q. O. A., FEBRUARY 12, 1911. Women had counterpart societies of the men's benevolent organizations. In this photograph, the ladies have organized a Japanese gathering and are seen wearing kimonos and Japanese headdresses. While much of the activities of the benevolent societies were for entertainment purposes, these organizations served as anchors to the diverse, growing communities in Telluride.

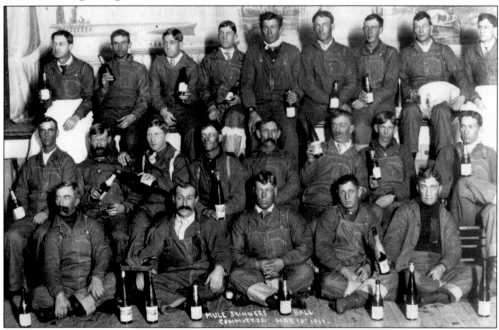

MULESKINNER'S BALL COMMITTEE, MARCH 10, 1911. During one of the era's most popular annual events, the muleskinners gather here in the Improved Order of the Red Men's Hall on south Fir Street. Muleskinner was the name given to men who ran pack trains.

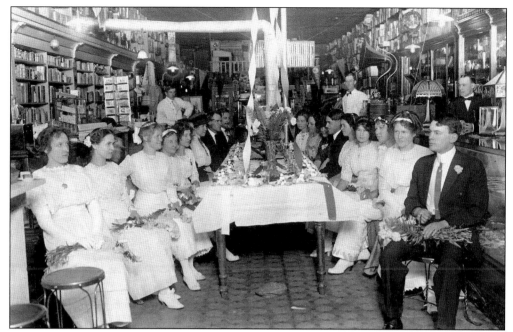

H. C. BAISCH DRUG STORE BANQUET FOR GRADUATING CLASS, 1913. High-school graduation was a watershed event for students and their parents, particularly because it often marked the highest education many in their families had ever received. Even more impressive, many of the students spoke no English when they entered the Telluride school system. An exterior view of the store in 1907 is seen on page 82.

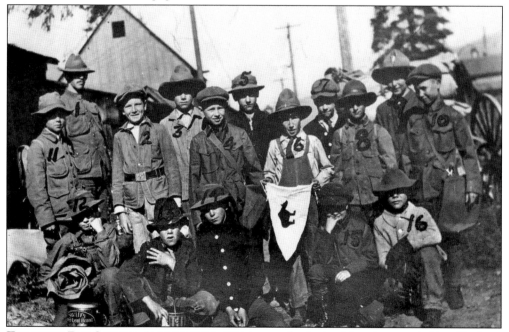

TELLURIDE BOY SCOUTS, AUGUST 1915. Writing on the back of the photograph identifies boys from the Segerberg and Quine families. Segerberg owned the Sheridan Opera House, and Quine had a business next to the Baisch Drug Store in the former location of the Cosmopolitan Saloon.

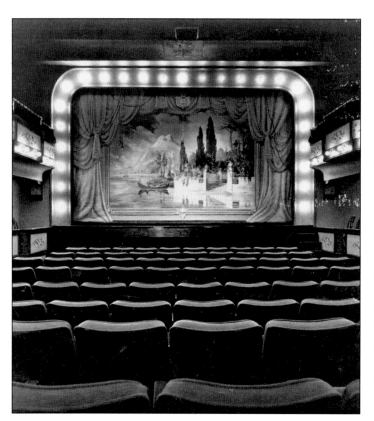

INTERIOR OF THE SHERIDAN OPERA HOUSE. W. A. Segerberg opened a 200-seat combination vaudeville and movie theater behind the New Sheridan Hotel in 1914. Crowned the Sheridan Opera House, it successfully attracted touring companies to the City of Gold. Sarah Bernhardt performed here. The roll-up curtain was painted with a Venetian scene by a known painter of the day. The acoustic quality of the Sheridan Opera House is prized. Today the renovated building hosts world-class musical and theatrical events, and the hand-painted screen has been preserved.

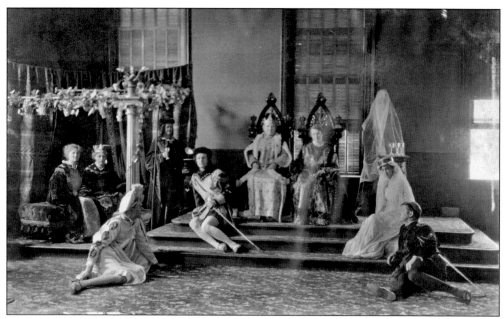

TELLURIDE FORTNIGHTLY CLUB. One of the women from the Van Atta family performs in this 1916 Shakespeare production on the second-story stage of the Masonic Temple Building, which still stands at 200 East Colorado Avenue.

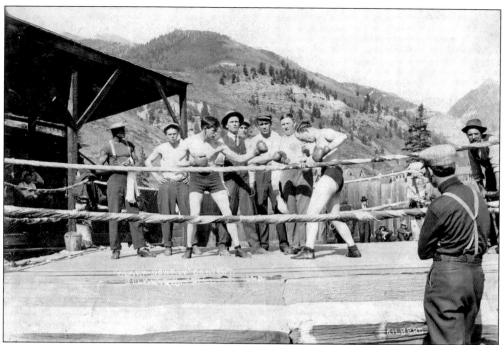

BOXING MATCH IN OUTDOOR RING. On July 4, 1910, Jack Dempsey boxed Pat Malloy, also known as the Tennessee Kid, in Telluride. Local legend has it that Dempsey, world heavyweight champion from 1919 to 1927, washed dishes and worked as a bouncer at the Silver Bell and Senate before his rise to fame. Dempsey is not, however, in this photograph of pugilists sparring during the Clark Downey boxing contest.

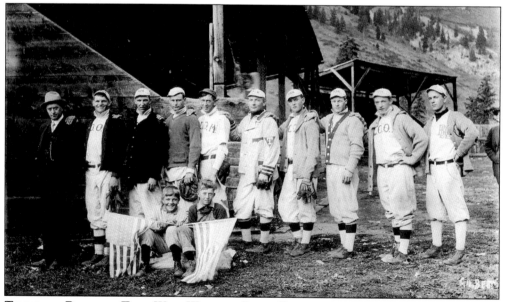

TELLURIDE BASEBALL TEAM WINS WESTERN SLOPE CHAMPIONSHIP. Baseball was a community event of the grandest scale. Telluride's teams practiced on the west side of town and won several championships. Teams visited from towns around the region, and the grandstand was often filled to capacity with fans.

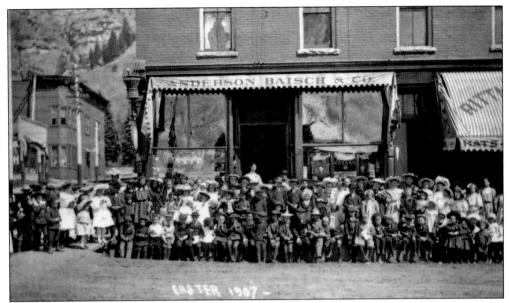

GATHERED IN FRONT OF DRUGSTORE FOR ANNUAL EASTER EGG DISTRIBUTION, EASTER SUNDAY 1907. After long, cold winters, Easter is a time of rebirth in Telluride. Days grow longer, and the sun does not disappear behind the mountains until late in the day. Community events like this were commonplace in the 1910s, often readily sponsored by town civic leaders. Renowned photographer Joseph Byers's studio is in one of the buildings seen on Pine Street in the background. Note the wooden boardwalk built over a deep gutter running alongside the dirt street.

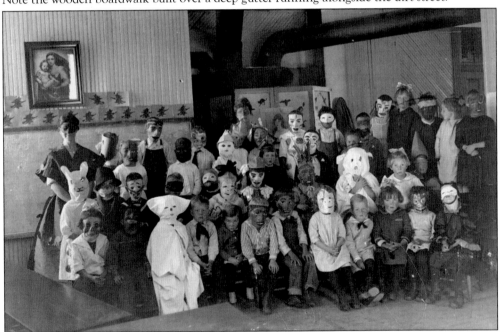

HALLOWEEN PARTY AT SCHOOL, 1922. Halloween is often snowy in Telluride and encourages mischief and mayhem. Even today, students wearing their Halloween costumes parade down Colorado Avenue each year. This photograph was taken at school and shows students donning homemade costumes. Telluride's annual Halloween party maintains an outlandish reputation.

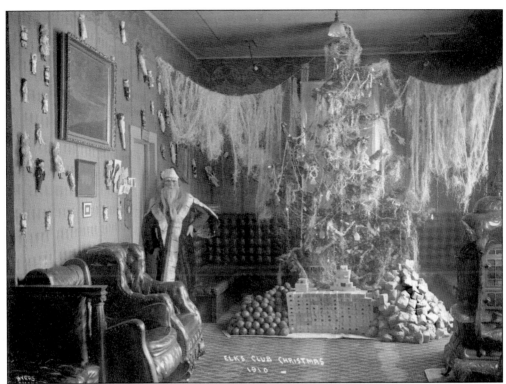

ELKS CLUB, CHRISTMAS 1910. In this photograph taken at the Elks Club above the H. C. Baisch Drug Store, a member of the Elks is dressed as Santa Claus. Waiting to be distributed to children in the community are Kewpie dolls on the walls, oranges, and small wrapped presents.

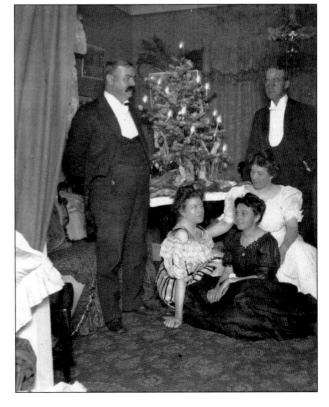

CHRISTMAS 1910. Pictured are Mr. Allen, Alice Gregory, Dessie Lomax, Mrs. Allen, and L. C. Lomax. Allen, a mine official, and Lomax, the boarding boss at the Tomboy Mine, a storekeeper, and Telluride's postmaster from 1912 to 1915, gathered at home with spouses and friends during Christmas. On May 19 of the year this photograph was taken, Halley's Comet had graced the night sky above Telluride.

Ress Home in East Telluride. Austrian immigrant August Ress prospered as owner of the City Bottling Works, where beer that had been shipped to Telluride in 55-gallon drums on the Rio Grande Southern Railroad was bottled. August and his wife, Freida, sit in the front seat of their car with children Raymond, Edward, Romilda, and Albert in the back seat. The Lone Tree Cemetery Survey indicates that Albert Ress was born in 1903. The Ress home remains on the 400 block of East Columbia Avenue.

Five

GOOD TIMES SOCIETY AND ITS UNDERBELLY

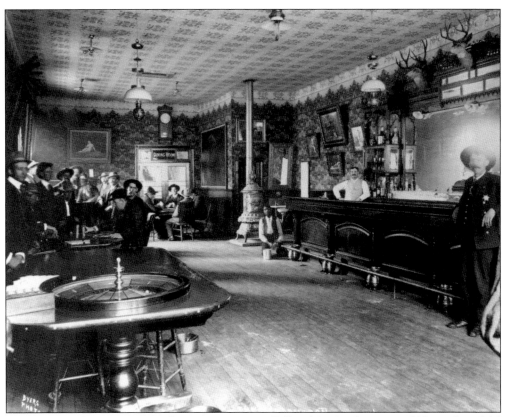

INTERIOR OF COSMOPOLITAN SALOON, C. 1905. Telluride's 10 saloons in 1887 numbered 26 by the mid-1890s. There were over 100 saloon keepers, and some prospered considerably. The Cosmopolitan was a sophisticated establishment located at 109 East Colorado Avenue and was frequented by merchants, lawyers, and mine officials. Its bill of fare listed "fine old California wines and champaigns." Papered walls were hung with art, and a hired hand kept the spittoon and brass rails polished. At the bar, lawman Kenneth Angus Maclean keeps an eye on things.

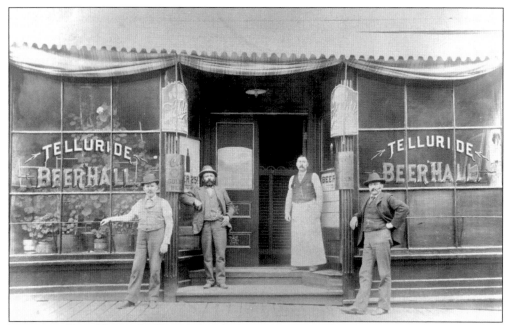

TELLURIDE BEER HALL. On West Colorado Avenue at Spruce Street, respected proprietors Oscar Wunderlich and Emanuele Visintin grew hops in the windows and sold beers for a quarter. Many saloons offered a free lunch with the purchase of a 5¢ beer. Action was constant as Telluride's bars, game parlors, and dance halls rollicked 24 hours a day, 365 days a year.

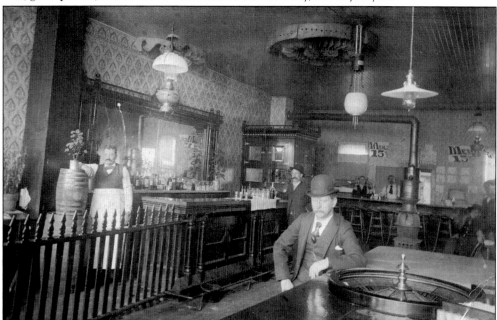

GRANDFATHER OLSON IN HIS SALOON. Miners' work was grueling. Liveries routinely delivered saddled mounts to the high country for workers' days off. Sometimes as many as 2,000 fun-seeking miners arrived in Telluride for the weekend. Telluride offered liquor, gambling, and female companionship in no short supply, and the streets were lit as brightly as their hopes. Grandfather Olson lived in Telluride from 1893 to 1907 and operated the Columbia Mine in 1905 and 1906.

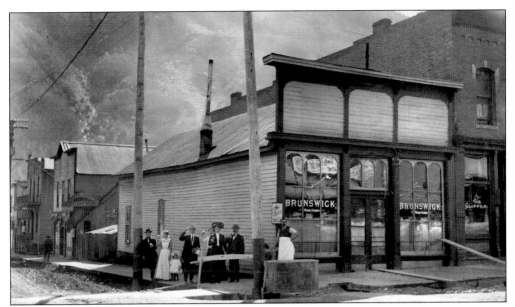

BRUNSWICK SALOON VARIETY THEATER AND BAR, SOUTHWEST CORNER OF COLORADO AND SPRUCE STREETS. Across the street from the Telluride Beer Hall and next to The Clipper was another popular watering hole and theater where traveling troupes of actors entertained. Here a group of actors toast the town. By 1960, the wild and bawdy past was barely an echo. A single Coors beer sign illuminated the nighttime on somber Colorado Avenue where over a dozen saloons once flourished.

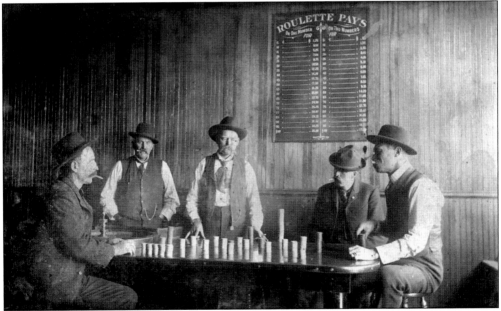

ROULETTE PAYS. Owners of gambling parlors enjoyed the same good credit with banks as other merchants. Many establishments were combination saloon and gaming parlor. Ornate slot machines of carved wood, with fancy painted-glass fronts and brass trim, stood around rooms, and the occasional hired band played. Miners could lose a month's wages in an evening of stud poker, faro, fan-tan, twenty-one, the hokey-pokey, and other games.

GOOD TIMES SOCIETY BUILDING. Telluride's red-light district thrived from 1897 until 1923 on East Pacific Street Avenue between Spruce and Pine Streets. The world's oldest profession had a direct economic function for the young municipality. Taxes levied on madams and some 170 "sporting girls" were thought to have contributed more to the town coffers than any other local industry. This former bordello on the northeast corner of Pacific Street Avenue at Spruce Street is adjacent to yesteryear's Popcorn Alley—a string of businesses where doors opened and shut frequently at all hours making the sound of popcorn popping. While the names of most miners and "sporting girls" are long forgotten, Telluride's gaming parlors, dance halls, and houses of prostitution were named to entice, including the Idle Hour, Monte Carlo, Big Swede's, The Cozy Corner, and Gold Belt.

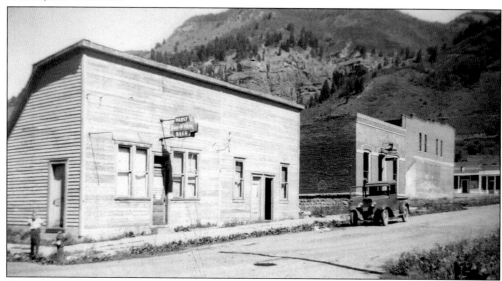

THE SILVER BELL AND SENATE NEAR POPCORN ALLEY. These former brothels have fascinating histories. In the heyday of "female boarding houses," 28 women "worked" the upstairs rooms of the Silver Bell, fetching $4 per client. Today this building hosts the Ah-Haa School for the Arts. Ladies of the evening rarely left the confines of the red-light district, but local merchants appeared in the afternoons to sell finery, and opium-smoking Charley Fong Ding took in their laundry.

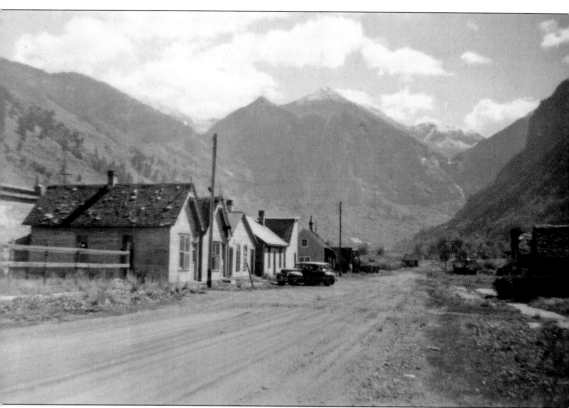

POPCORN ALLEY CRIBS. Originally each crib housed a single woman who would display herself in her front window. Services were rendered for $2. Many prostitutes were lured by hired female recruiters who traveled the country misleading young girls by promising work in Telluride shops and offices. Their marred lives typically ended in sorrow. Alcohol, drug abuse, and suicide were frequent escapes. Disease was a constant threat, especially syphilis, which was rampant. In the 1920s, the cribs were painted red. Some of the cribs have been moved to other locations in Telluride, and only a few remain today.

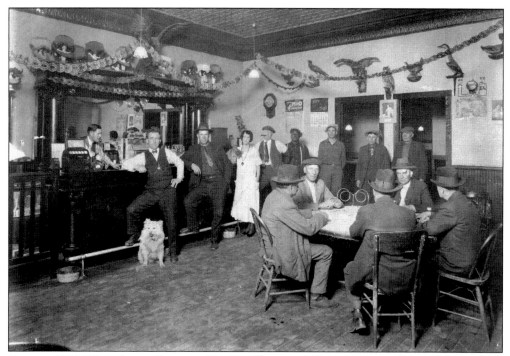

SENATE, 1921. The culture of bars, gambling, and houses of ill repute persisted beyond the 1920s in Telluride. The Senate maintained its faro table until the 1970s, and its original bar is in the building today. The Senate also had the distinction of being run by one of Telluride's most well-known madams, Big Billy, who was known to literally throw patrons out on the street for non-payment. Pictured here is owner Barney Gabardi who, with his wife, Rita, prospered in Telluride.

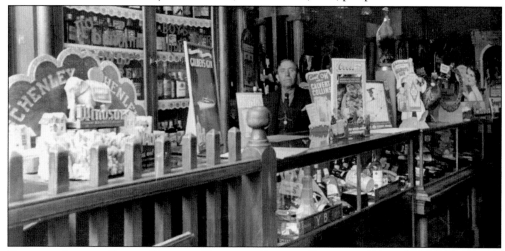

BELMONT LIQUOR STORE, BARNEY GABARDI, OWNER. Barney and Rita Gabardi, originally from Italy, owned many Telluride properties, including the Senate Bar, Silver Bell, and several red-light district bordellos, which Mrs. Gabardi kept rented to madams. While friendly with the "girls on the line," she was at the same time all business. Leary of banks, Mrs. Gabardi was said to carry her money on her person under a big fur coat she was rarely seen without. Barney was stately, dapper, and well liked, while some found Rita terse. The Gabardi's held Telluride properties into the 1970s.

Six

UNLEASHED
POWER, POLITICS,
STRIKE, NATURE'S FURY

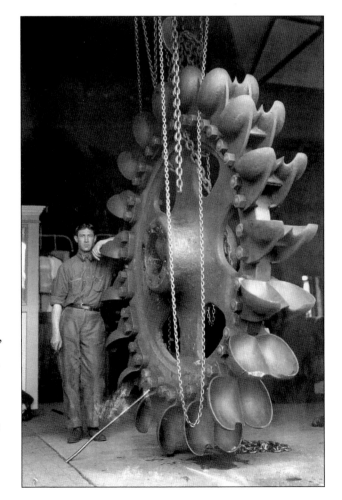

PELTON WHEEL AT AMES POWER PLANT. Mines required vast amounts of fuel to operate. With forests denuded and the importing of coal costly, Telluride mines faced severe deficits and closure by the late 1880s. Fortunately necessity is the mother of invention. In 1891, Lucien L. Nunn of Telluride changed the course of electricity and history in one fell swoop. This Pelton Wheel, a landmark of turbine technology in its day, was used at Nunn's hydroelectric power plant in Ames, which successfully produced the world's first commercially used alternating current electricity.

L. L. NUNN HOUSE AT COLUMBIA AND ASPEN STREETS, C. 1890. Nunn, a mine and bank official, attorney, and entrepreneur, proposed a scheme to George Westinghouse and electrical genius Nikola Tesla, a Croatian immigrant, to transport alternating current (AC) electricity from the Ames Power Plant to power the Gold King Mine, which he owned in the Alta Basin. Nunn hired a team of Cornell University engineering students and housed them next door to his Telluride home. Both homes are still standing at Columbia Avenue and Aspen Street. Nunn's electrical empire grew beyond the Telluride region, and he employed the students to run his power plants, tracking their whereabouts using pushpins on a map. As a result, these students were nicknamed "Pinheads."

POWER STATION ORIGINAL BOX AT AMES. Nunn was motivated to solve expensive fuel challenges because he owned the nearby Gold King Mine in the Alta Basin. This small Ames plant housed the first generator fueled by water from Howard's Fork. A water-bearing flume can be seen on the hillside behind. Flumes, enclosed wooden boxes that were miles long, carried water to and from the generator stations. A lifeline, flumes required careful maintenance, and "flume walkers" were hired to traverse the line with putty knife and oakum making repairs in good weather. Some lines had high trestles to maintain that were periodically threatened by mud slides and snowslides.

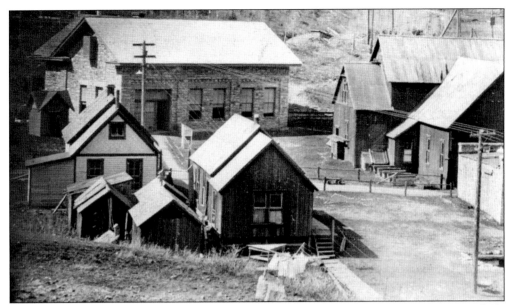

AMES POWER PLANT AND LIVING QUARTERS. The Ames Power Plant successfully and dependably electrified the Gold King Mine. Energy costs were reduced by thousands of dollars. A power line was strung from Ames, across Ophir, to Telluride in 1892, making Telluride the first town in the world to be lit with alternating current (AC) electric streetlights. The original power line is visible from the Nunn house and today is a ski run named "Powerline." It is clearly seen in the top image on page 124. The large stone building in this photograph replaced the original power station that burned down.

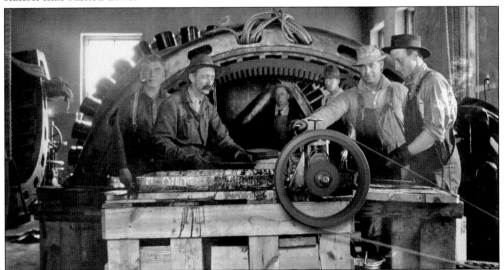

SIX MEN REWINDING ARMATURE AT AMES. Direct current (DC) electricity flows in one direction at a constant, unchangeable voltage and does not travel efficiently over long distances. Alternating current (AC) reverses direction at regular intervals and can be stepped up or stepped down by transformers for varying voltages. It can move long distances over thin silver or copper wire, as confirmed by Nunn's venture. The men here are winding copper wire, which carries the current achieved by the turning Pelton Wheel. The Ames plant continues to produce electricity today and Pelton Wheels are used throughout the world.

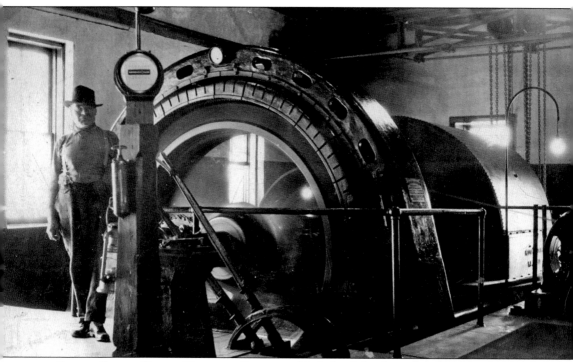

ILLIUM POWER PLANT NICHOLAS SCHOOLS. Nicholas Schools, a plant boss at one of Nunn's generator stations, and his wife lived at Ames. The Ames community was made up of power-plant workers whose lives were made all the more remote by the steep, hairpin-road into Ames.

FORT PEABODY ON THE DIVIDE BETWEEN IMOGENE BASIN AND SAVAGE BASIN. Between 1901 and 1904, Telluride saw one of the United States most contentious wars between capital and labor. Cries of "slave-wages" from the Telluride mine workers threatened mining empire owners, backers, and the State of Colorado, especially when Smuggler-Union miners went on strike in May 1901. The mine had sent nearly $1 million in bullion to the Denver Mint the prior year, while miners struggled to make ends meet. Fort Peabody, seen here, was erected in 1903 to prevent exiled strikers from returning over Imogene Pass during a protracted period of martial law.

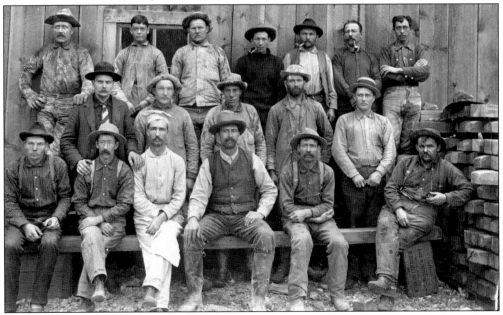

MINERS AND COOK IN FRONT OF BOARDINGHOUSE. Immigrants provided almost limitless cheap labor while mine officials dined in splendor at the New Sheridan and took European vacations. Miners were paid $3 a day for eight hours of work in paltry, dangerous working conditions. Because Telluride was gold rich, it had survived the repeal of the Sherman Silver Purchase Act in 1893. Telluride's financiers included Rockefeller, Rothschild, and Whitney.

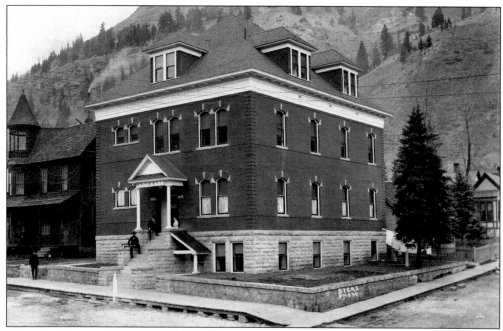

MINER'S UNION. To ride out the strike years, the Telluride Miner's Union was built as a hospital and labor headquarters to shelter strikers who could be deported during the long period of martial law decreed by Colorado governor Peabody. Today the Miner's Union has been converted to condominiums.

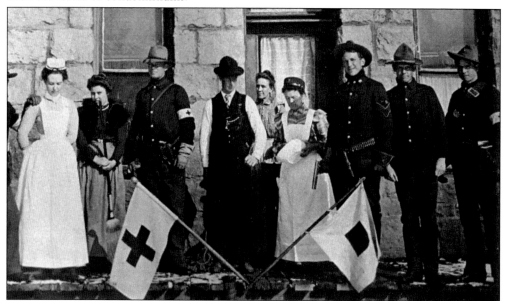

MILITIA MEN AND NURSES AT THE TELLURIDE COMMUNITY HOSPITAL, C. 1903. During the conflict, Telluride was occupied by armed militia, and the hospital stopped serving union workers to treat the militia. A pass was needed to walk the streets, and houses could be searched at will. The New Sheridan Hotel quartered some members of the military, and Charles Moyer, a mining union leader, was imprisoned there for months. His release was ordered by the state's high court, but the order was summarily ignored by Telluride's civil and military officials.

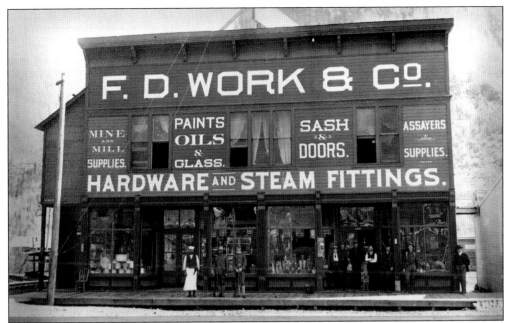

DOUGHBOYS OF NATIONAL GUARDSMEN ON MAIN STREET. Military rule grew as did union memberships, which swelled from 350 to 1,600 by the spring of 1902. F. D. Work and Company and other merchants needed mines open to make a profit. Most opposed the unions. The town's two newspapers stood on opposite sides of the debate.

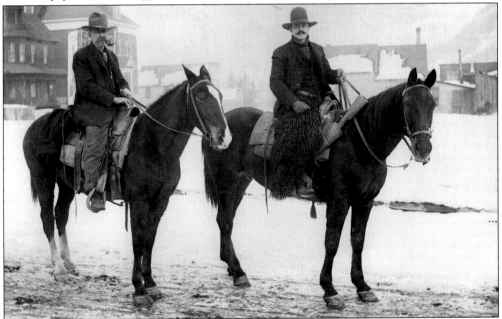

TELLURIDE SHERIFF CALVIN RUTAN AND DEPUTY. The Miner's Union building is seen behind Sheriff Rutan in this photograph. Rutan deputized several individuals known as "lightening on the draw" and "bad men of Western legend" to control the streets of Telluride. He ignored court orders and helped mining management and the military thwart the union's every attempt to regain a foothold in the fight for miners' rights.

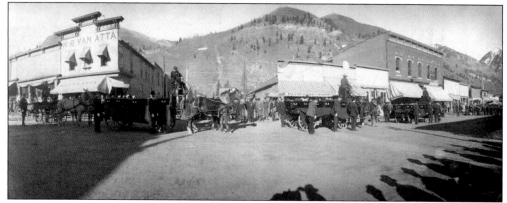

FUNERAL PROCESSION ON COLORADO AVENUE. Starting a bad round of events, President McKinley was shot and died on September 7, 1901. Then on November 20, 1901, the Smuggler-Union Bullion Tunnel burned, suffocating 24 miners when smoke was sucked down mine shafts. This photograph shows only a few of the thousands of mourners who took to the streets of Telluride. It was the worst mining-industry accident Colorado had seen. In February 1902, an explosion killed two Japan mine workers in the Tomboy basin, and then on March 1, 1902, the infamous Liberty Bell Slides caused 21 deaths.

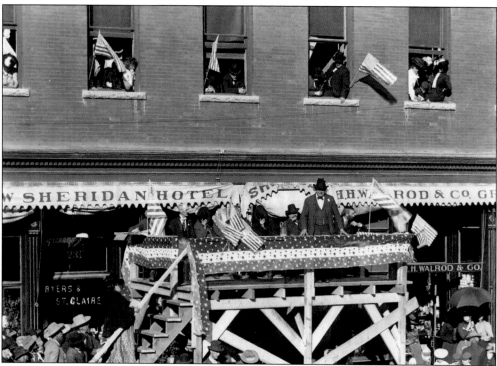

WILLIAM JENNINGS BRYAN REPRISING HIS "CROSS OF GOLD" SPEECH. Invited by the Telluride Businessmen's Association, in October 1902, Bryan spoke on "the evils of socialism" and reprised his famous 1896 "Cross of Gold" oration. While physically remote, Telluride's place on the national scene was not. In an ironic twist, even though many of the miner's original grievances were eventually met, the Telluride Miners Union was squashed in the end and corporate interests were well served. The final cost of imposing martial law to government and industry was just over $200,000—a bargain in light of revenues reaped in the high country.

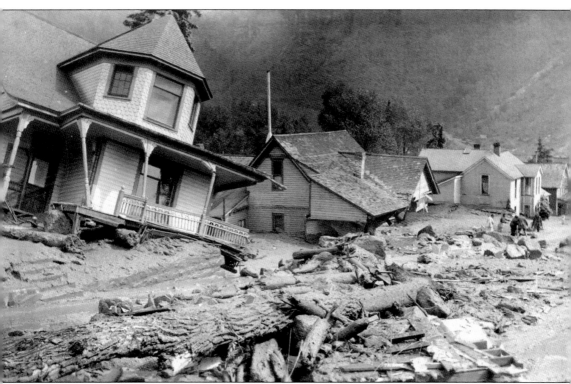

MUD, ROCK, STICKS, AND FLOOD DEBRIS ON OAK STREET, 1914. Dramatic July cloudbursts mark Rocky Mountain afternoons, but on July 27, 1914, one such cloudburst left destruction and terror in its wake. Cornet Creek became a sluice for tons of mud and debris from above, much of it out of the Liberty Bell Mine where ground was loose and tailings were deep. Trees and boulders were tossed like toys, Colorado Avenue was in ruins, houses were flipped off foundations, and businesses were buried. Remarkably there were but two casualties, a woman and her dog.

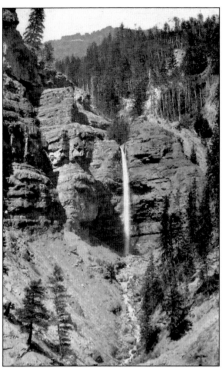

CORNET FALLS. Cornet Creek, spawned high in the mountains, narrows above Telluride into a spindly but powerful waterfall that descends 200 feet past a magnificent wall of red sandstone. Its grandeur is noteworthy, but so is its fury. Cornet Creek's power has wreaked havoc on Telluride in two mighty floods, the first in 1914 and again in 1969, where rushing walls of mud and debris covered streets and neighborhoods. While it could happen again, Cornet Creek has been diverted, in part to mitigate possible future flood damage.

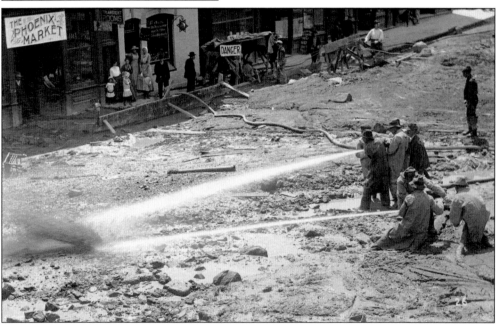

A. W. SEGERBERG AND TOMMY RUNDLE RUNNING HOIST DREDGE USED IN CLEARING THE NEW SHERIDAN. The noon-hour flood rushed furiously down Oak Street and spread muck and pasty sludge blocks wide. Afterwards ingenious Telluride miners diverted the creek flow into the alley between Oak and Fir Streets where they fashioned wooden flumes to feed fire hoses used to remove debris. The Phoenix Market hung up a new sign during the cleanup to let everyone know they were open.

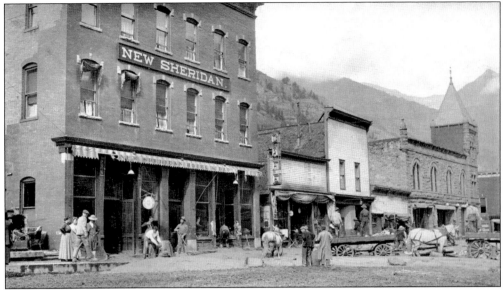

FLOOD DEBRIS ON MAIN STREET, 1914. Water and mud literally swept in the back door of the New Sheridan and out its front. The block housing the New Sheridan Hotel and First National Bank was a focal point of town. Furniture was removed and stacked against walls as men got busy cleaning up debris with shovels. Typed on the back of this image is "Lindgren: New Sheridan Hotel where I was employed as a night clerk while in high school, 1914." Arthur Lindgren graduated from Telluride High School in 1916.

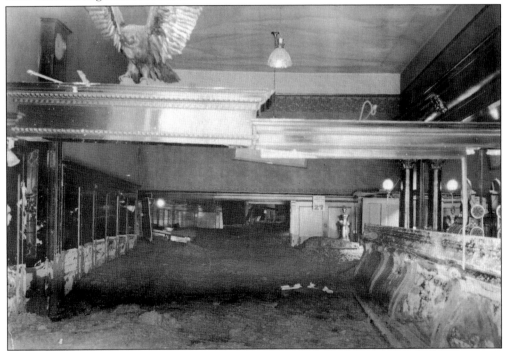

INTERIOR OF NEW SHERIDAN BAR FILLED WITH FLOOD DEBRIS. The bar was knee-deep in mud, not customers, after the flood of 1914. An ornate stove peers out from the debris while mirrors and light fixtures stand witness.

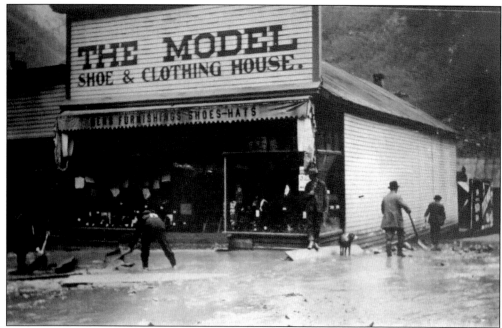

THE MODEL SHOE AND CLOTHING HOUSE WITH FLOOD DEBRIS IN STREET, 1914. Debris made its way to both ends of the commercial district. This gentlemen's store on Colorado Avenue at South Fir Street, site of the original courthouse, not only survived but is seen on page 110 during a July Fourth event. The building vanished sometime later, and the corner stood bare for decades.

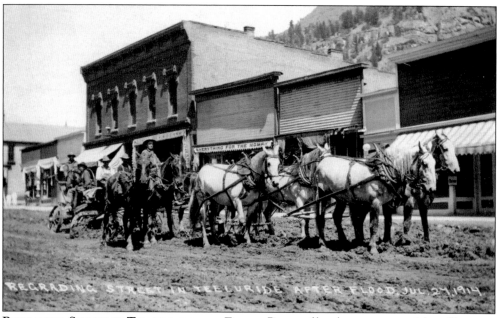

REGRADING STREET IN TELLURIDE AFTER FLOOD. Beasts of burden were essential to all aspects of Telluride in the best and the worst of times.

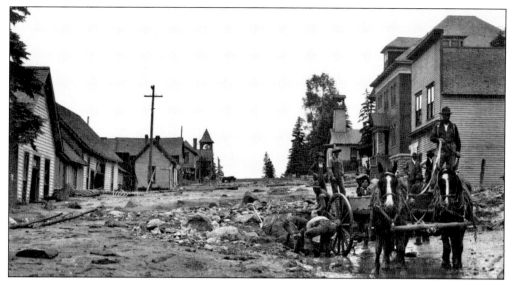

Horse-Drawn Wagon Cleaning Flood Debris on Columbia Avenue. Residential neighborhoods were hard hit. Fortunately the flood happened at noon and many people were inside having lunch. Those outside ran for their lives. The Miner's Union, Rebekah Hall, and the original Methodist church are pictured here on Columbia Avenue looking west from the block between Spruce and Pine Streets.

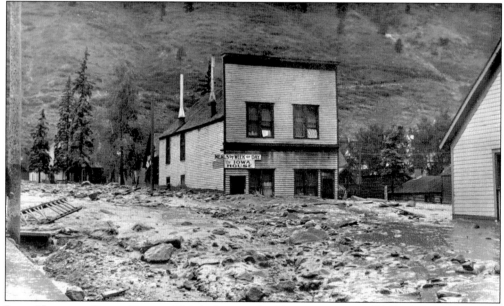

Iowa House in Flood Debris. This is the same building seen on page 76. By this time, its name had changed. It is pictured here, the first building at right.

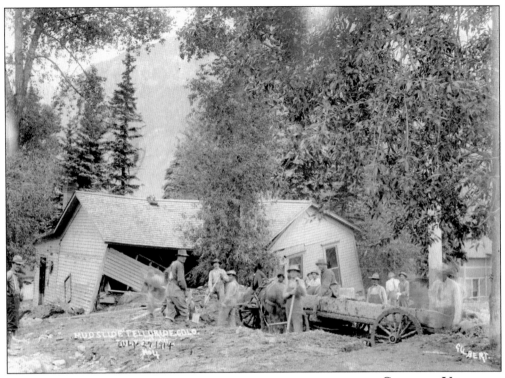

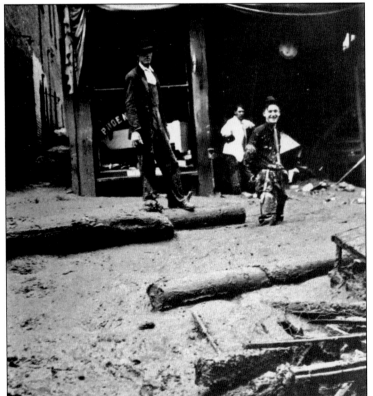

CLEANING UP AFTER 1914 FLOOD. The only two casualties of the day were Mrs. E. E. Blakely and her dog. It is believed that she had run back into her house to get her dog and both were swept away. Her body was not discovered for almost 70 hours.

THREE MEN ON STREET IN FLOOD DEBRIS. Up to their knees in mud but with spirits unbroken, jovial men gather on Colorado Avenue with the Phoenix Market behind.

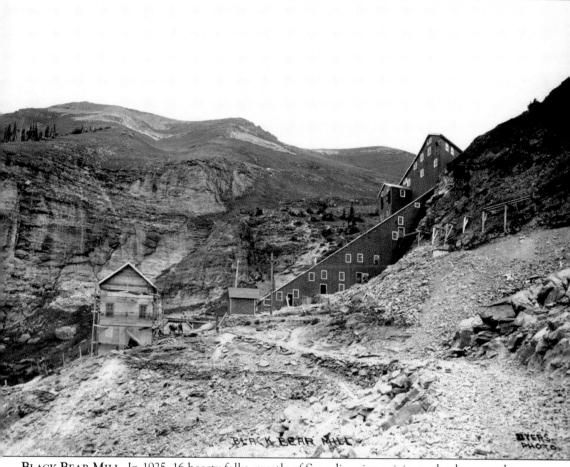

BLACK BEAR MILL. In 1925, 16 hearty folks, mostly of Scandinavian origin, took a lease on the Black Bear Mine, which sits precipitously high on the wall of Telluride's box canyon above Ingram Falls. The mine, originally held by a group of Finnish immigrants who did well with the venture, was defunct by the mid-1920s. The mine's boardinghouse had stood for decades, strategically built between slide zones. Winter was ferocious when the group was there, and the avalanche chutes were precariously full of snow. When two avalanches ran down the mountain around 3:00 a.m. on April 2, 1926, they broke the boardinghouse in two, killing Ed and Marie Rajala. Rescuers were led to their bodies by a strand of green yarn trailing from Marie's knitting that had been beside the couple's bed.

WOMEN ON A SUNNY DAY BELOW AJAX. Mrs. George Hicks and Mrs. Donald Gifford were neighbors at the mine complex in Pandora. Here they are on their porches with children and dogs. In 1928, they were killed by an Ajax Mountain snow slide or "avalanche," a word not often used in that day.

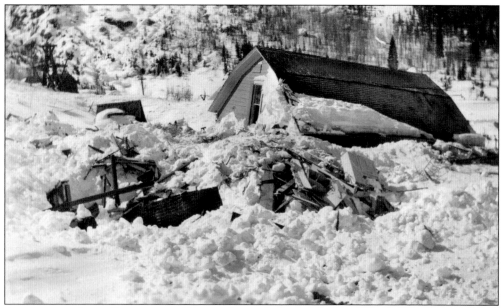

AVALANCHE SNOW SURROUNDS HOUSE. Irene Gifford was planning a party despite having boarded the windows in the rear of her house in case of a snowslide. The worst happened at 10:00 one morning in March 1928 when Mrs. Hicks and Mrs. Gifford's deaths were caused by an Ajax Mountain snowslide. Two-year-old Donald Gifford survived; he and his father, a mine bookkeeper, soon left the Telluride area.

Seven

A LOVE AFFAIR WITH THE FOURTH OF JULY

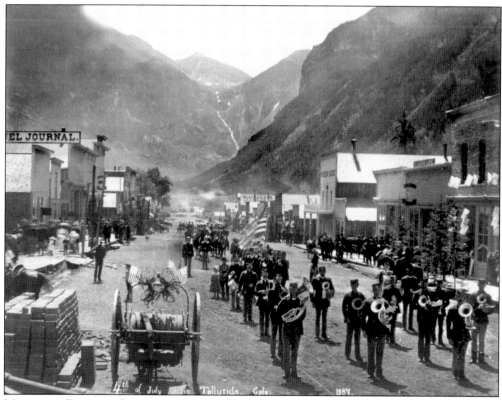

MARCHING BAND ON COLORADO AVENUE, FOURTH OF JULY, 1887. The town has celebrated this holiday as one of the year's biggest events since 1884 when Telluride was still named Columbia. Mines ceased operating on the third and fourth and folks came, and still come, from surrounding counties for games, dances, and parades. The fire department has always played the central role in the festivities. Mostly volunteers, it has always been this organized, dedicated group that kept disaster at bay and brought the town together to celebrate Independence Day. Here amidst flying flags is the fire department's hose cart. Huge brass fire trumpets were undoubtedly also blaring. The Fourth of July in Telluride is an annual homecoming, and everyone looks forward to the spectacular parade and Telluride Fire Department–sponsored picnic and fireworks display.

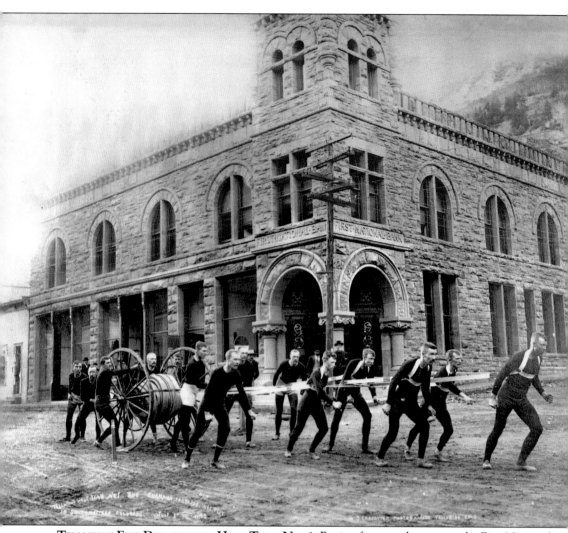

TELLURIDE FIRE DEPARTMENT HOSE TEAM NO. 1. Racing firemen charge past the First National Bank on July 3, 1892, on the way to the finish line where they were declared champions of the Wet Test Contest of Southwestern Colorado. Because mining camps, mills, and early settlements were built primarily of wood and fireplugs were yet to be designed, an efficient fire department was essential. The building is standing today and has the stained-glass windows seen above the first-floor corner doors.

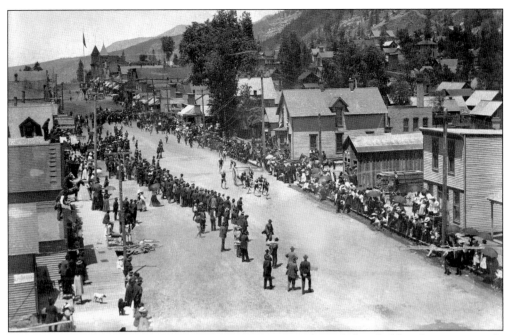

HOSE RACE AGAINST TIME, FOURTH OF JULY, 1898. Under a Colorado blue sky, townspeople cheer a hose team dashing down East Colorado Avenue. Their breakneck clip commenced after a pistol shot started this timed hose-cart race.

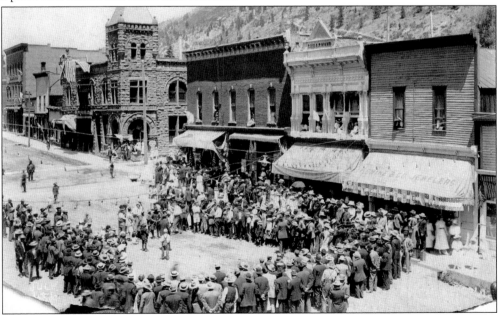

MAIN STREET, FOURTH OF JULY. Electric wires are strung above this large crowd in the commercial center of town. Seen where Colorado Avenue and Fir Street intersect are the Telluride Electric Light Company, First National Bank, Busy Corner Pharmacy, Mahr Building, and J. F. Quine and Company. The Mahr Building replaced the wooden San Miguel County Bank, robbed in 1889 by Butch Cassidy and his gang, while the Quine storefront marks the old location of the famed Cosmopolitan Saloon.

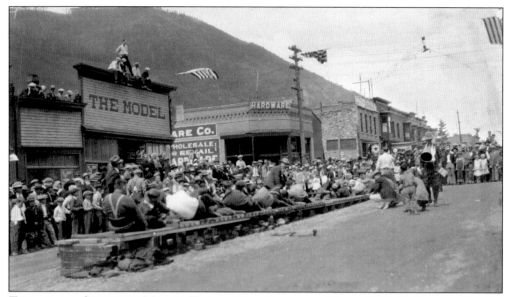

TOMBOY AND SMUGGLER MINERS TUG-OF-WAR, FOURTH OF JULY, 1926. Bullhorn at his side, a man watches as Tomboy Mine and Smuggler Mine employees compete in front of The Model and people sit atop buildings to watch the competition. The corner building with a hardware sign became a bowling alley in the 1950s; for most of the last 20 years it has been known as the Excelsior Restaurant. The model is also pictured on page 102.

MINING TUG-OF-WAR, FOURTH OF JULY, C. 1950. Mining had begun to wane in the San Juan Mountains when this photograph was taken, but Colorado still had a strong mining culture. Although several mines and mills remained open in the Telluride region, output would never be equal to that of the 1890s.

JULY FOURTH WATER FIGHT, C. 1950. In addition to tugs-of-war between miners, fire departments competed in front of the San Miguel County Courthouse, turning fully pressured fire hoses on each other until one team was pushed behind a line painted on the street. Early on the morning of July Fourth, the "Powder Monkeys Breakfast Alarm"—a dynamite blast set off by the fire department—started the day's festivities. Children's activities were legendary—pie eating contests, catching fish in a barrel, one-legged races, egg tosses, and more.

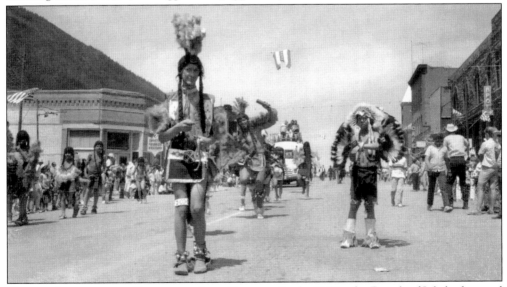

NATIVE AMERICANS IN FOURTH OF JULY PARADE. By the 1950s, the Fourth of July had turned into a three-day event. The parade featured cowboys, marching bands, floats, and more. Here Native Americans dressed in Pow Wow costumes carry twisting snakes while a bus with huge drums being played on top is seen behind them. Ironically Native Americans frequented Telluride's festivities even though it symbolized the westward expansion responsible for their many losses.

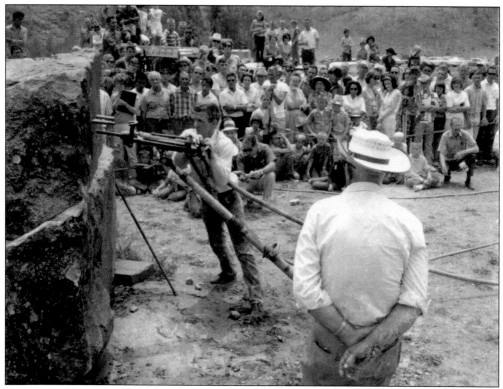

DRILLING CONTEST, FOURTH OF JULY, 1950. In the 1950s, hard-rock miners held drilling contests using powerful jackhammers connected to pneumatic hoses. The fire department began a tradition about this time of holding a barbecue picnic in the town park. They started roasting the pork a day earlier in a huge spit they built. Today residents and visitors alike continue to enjoy this tradition.

WINNER OF FISHING CONTEST, c. 1960. A huge tank of water was brought in on a truck, and children would "fish" in it with their bare hands. This is still a feature of the festivities held on the Fourth of July in Telluride.

Eight

CALM BEFORE THE STORM

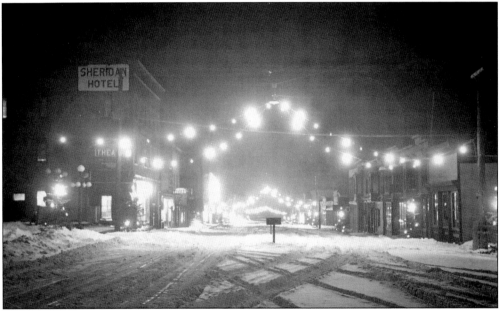

COLORADO AVENUE DECORATED FOR CHRISTMAS. Whether in good economic times or bad, Telluride's holidays have been special. Early in the 20th century, residents gathered under a large decorated tree placed on Colorado Avenue and sang carols as community gifts were passed to all. On the back of this photograph is written, "Notice the Coasting Signs." When these signs were posted in the middle of the street, children (and adults) coasting, or sledding, on Oak Street had the right of way. The years between the late 1920s and the advent of the ski area were quiet. Jobs were scarce, and Telluride's population dwindled. During the Depression, money and jobs were almost nonexistent and many abandoned their homes. Taking nothing with them, they left houses filled with personal possessions as if time had stopped. A combination of events shattered the boom times, and Telluride mining never recovered.

HILDA RAMSEY, JUNE 1931. The nine-hole golf course was located three miles west of Telluride where traffic enters the Lawson Hill business district today. The course was on the old Boston Placer. Up the hill, where the Mountain Village entrance is today, enterprising Finn's opened a fox farm but made no profits on the pelts they tried to produce. By this time, the Depression was in full swing and the major mines and mills closed. Even dairy farmers were leaving the valley. Hilda Ramsey, posing here, was from an old Telluride family.

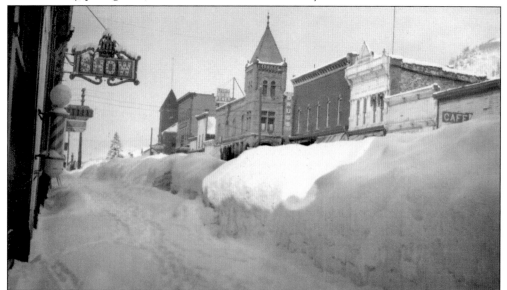

MAIN STREET IN WINTER. Telluride grew very quiet with some 500 people in town in the 1930s and 1940s. World War II drew young men out of the community, and the war effort included the stripping of scrap iron. Consequently the buildings at mills and mines were decimated, destroying one of this country's most unique architectural legacies. Mining limped along, and those who remained in town gathered for bazaars, potluck dinners, and dances held at the courthouse and school.

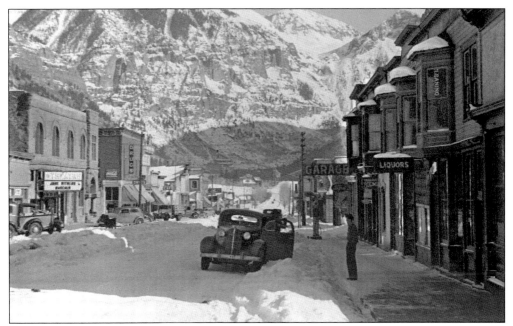

WINTER SCENE, COLORADO AVENUE. Shadow is just creeping across the canyon in this c. 1940 photograph taken midwinter and looking east on Colorado Avenue. The tower on the First National Bank building had been removed due to age damage. Note the familiar Texaco Star identifying the gas station. Today no gas station exists in town. In those days, the center of town was so quiet bonfires could be lit after school football games, and celebrants were known to snake dance right down Colorado Avenue.

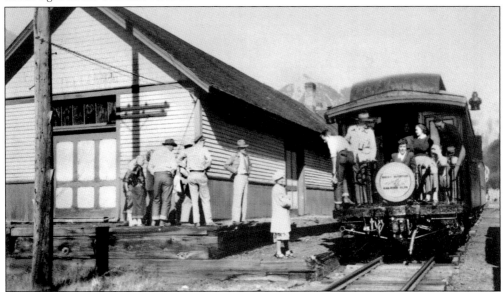

ROCKY MOUNTAIN RAILROAD CLUB, 1947. In the years after World War II, Colorado was very popular with sightseers because well-preserved mining towns and railroads offered tangible glimpses into history. Here well-dressed rail buffs enjoy a moment on the west side of the Telluride Depot platform. In the autumn of 1951, the Rio Grande Southern Railroad stopped operations, and by 1960, its tracks had all but disappeared from Western Colorado.

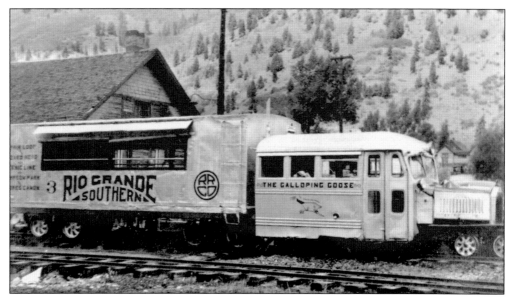

GALLOPING GOOSE NO. 3 AT TELLURIDE DEPOT. Passenger trains were too costly to maintain, so in 1931, the Rio Grande Southern introduced the "Galloping Goose." The first Goose was fabricated from the body of a Buick in 1931. The fleet was ultimately expanded to seven, with each new Goose an improved-upon design. The "Geese" galloped through the San Juans carrying the U.S. mail, passengers, and freight until the 1950s. Today Galloping Goose No. 4 sits just west of the San Miguel County Courthouse in Telluride. Its nearly 15,000 pounds looks both whimsical and strong as an ox.

GALLOPING GOOSE NO. 3 AND PASSENGERS. Locals and tourists alike used the Galloping Goose to travel into the Lizard Head Wilderness, between Ophir and Rico, for adventure, picnicking, and gathering mushrooms in the crystalline mountain air. This photograph was taken from the water tank at Trout Lake.

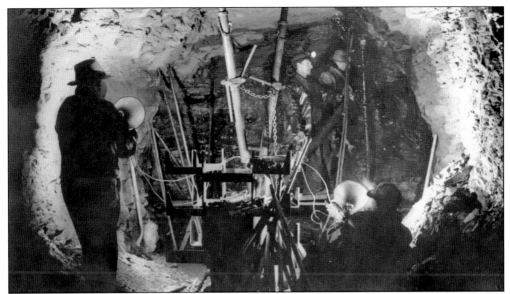

MINERS IN TUNNEL, C. 1940. In 1932, a group of Denver investors, lead by Ben Grimes, bought the Smuggler-Union Mill that had been closed since 1928. It operated as the Telluride Holding Corporation, was then named Vesta Mines, Incorporated, and in the 1940s it was Telluride Mines, Incorporated. Industrial efforts associated with World War II boosted extraction of base metals lead, zinc, and copper from the Smuggler vein. In this photograph, miners "drive a drift," a procedure that drills and blasts a horizontal tunnel into the mountain. The Idarado Mining Company purchased Telluride Mines in 1953. In 1978, the profitability of mining plummeted and operations ceased. The equipment used in the mill was removed and its gates were locked.

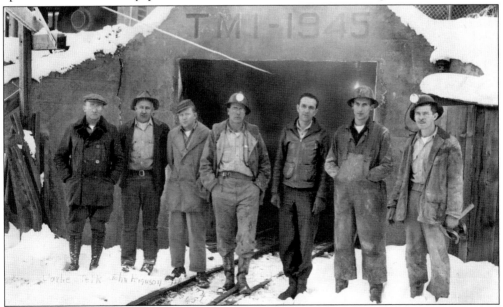

MINERS AT PANDORA, 1945. Charlie Telk, at left, was commissioned by Telluride Mines, Incorporated to drill a pipeline from Blue Lake to fuel a hydroelectric plant. When the water was initially released, it immediately broke a retaining door and drained the lake. Repairs were made, the lake was refilled, and operations resumed.

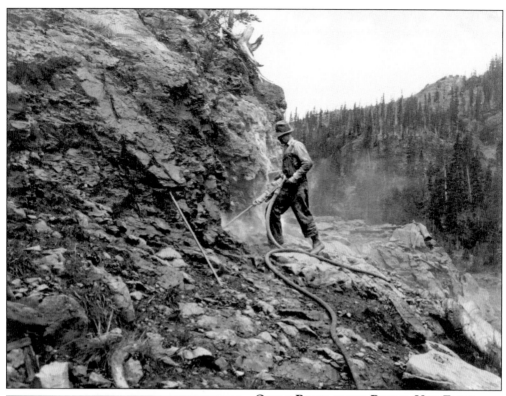

OSCAR BLIXT ABOVE BRIDAL VEIL FALLS.
The blixt brothers, Oscar, Harry, and Gator, prospected and mined in Bridal Veil and La Junta Basins into the 1950s. Oscar and his wife, Lena, used a swinging lantern at night to communicate with each other between her porch in Telluride and his work site in East Bear Creek Canyon.

SIGHTSEERS AT AN OLD GOLD MILL.
Abandoned mines and mining towns were central to Colorado tourism in the 1950s and 1960s. In Telluride, the former town dump, located where the base of Lift Seven is today, was filled with colored glass bottles, tobacco cans, flour tins, old china, etc. In the 1960s, the dump became overly popular with scavengers, and the town council voted to ban anyone from scavenging there.

Nine

LITTLE-KNOWN FACTS

DR. GEORGE BALDERSTON IN HOSPITAL. Featured in *Ripley's Believe it or Not* is Dr. George Balderston's self-appendectomy, which he performed in 1949 in the Telluride American Legion Hospital, now home of the Telluride Historical Museum. As a means to test his merits as a surgeon and to rebuke a claim that he had "butchered" a patient, Dr. Balderston decided to operate on his own appendix, which had been giving him trouble for some time. Just one day after the operation, Dr. Balderston was tending to patients.

PLACERVILLE STOCKYARDS, PLACERVILLE, COLORADO. Because of the Rio Grande Southern Railroad and its location at a crossroads, Placerville, Telluride's neighbor, became one of the region's greatest cattle yards. Ranchers from Norwood, Lone Cone, and beyond brought their herds here to be shipped to market.

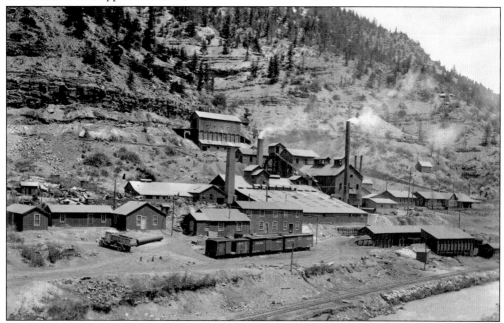

PRIMOS CHEMICAL COMPANY MILL, VANADIUM, COLORADO. Arriving by ship in the United States from France in the 1880s, Madame Curie visited Telluride with her husband, Pierre. Miners were miffed when the strangers asked to buy tailings from the Vanadium mill site west of Telluride along the banks of the San Miguel River. The Curies were studying elements, and Telluride offered them fresh samples from deep inside the earth. In Paris, the Curie's discovered radium in the fine ore from Colorado, and the rest is history.

120

NATIONAL CLUB ON COLORADO AVENUE. Telluride practiced temperance from time to time, mostly with unimpressive results. During Prohibition, bars posing as "soda parlors" were plentiful. Salvation Army troupes appeared in front of the National Club, where the infamous Last Dollar Saloon is now, and sang hymns beguiling miners and denizens of Telluride. Then the women of the troupe ambled about with tambourines, collecting gold and silver coins from onlookers.

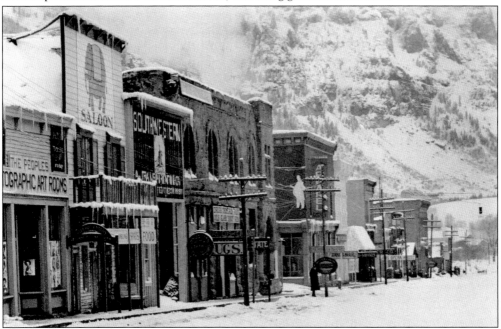

MAIN STREET AS SETTING FOR MOVIE *BUTCH AND SUNDANCE: THE EARLY DAYS.* Movie crews from 20th Century Fox came to town in 1978, filming in and around Telluride and recruiting local actors and actresses. Snow (and plastic icicles) were Hollywood-added touches. The elephant sign pictured here was painted for the movie and remains today. Fiberglass Hollywood skis for skiing scenes lacked camber so local Joe Pacal, who played Sven Torgerson, used long wooden antique skis like the ones seen with Homer Reid on page 123.

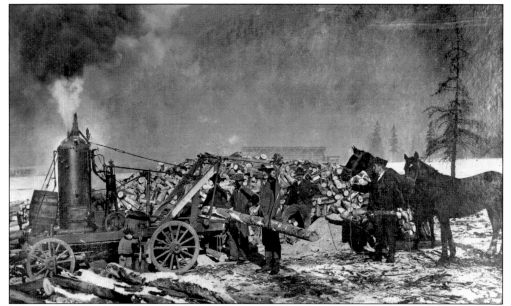

SAWING WOOD NEAR DAVIS PARK IN WEST TELLURIDE. This contraption has been called a Go-Devil and a Steam Jenny. What ever its real name might be, this Telluride innovation is a direct result of its mining heritage.

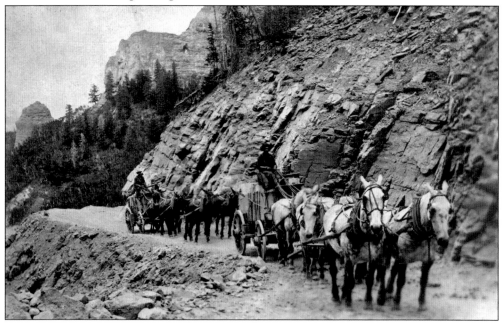

MULE TEAMS ON TOMBOY ROAD. The sound and smell of animals was constant throughout early Telluride. Muleskinners packed their animals artfully to maximize loads and prevent hurting the mules because their livelihood depended on them. In *Tomboy Bride*, Harriet Fish Backus comments on the state of the animals she saw when living at the Tomboy Mine, a time when mine-tunnel mules spent their lives underground and often went blind. Riders were known to whip horses rented from liveries until their skin was broken, rushing the animals down steep mining roads in a hurry to reach the delights of Telluride.

Ten

WHITE GOLD

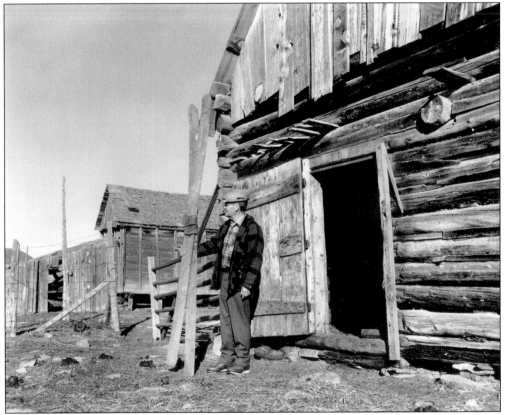

HOMER REID WITH OLD SKIS FOUND IN BARN ON LAST DOLLAR ROAD, MAY 1964. One of Telluride's well-known photographers and archivists holds the future of Telluride in his hands. Ten years later, in the nascent ski town of Telluride, residents stood skis in front of their homes to signal to a circulating bus that drove them to the newly installed ski lifts in Mountain Village. This pair of long wooden antique skis was originally displayed in the San Miguel Historical Museum, now known as the Telluride Historical Museum. Arlene Reid, Homer's wife, was the original director of the museum in 1966 and her curatorial efforts added immeasurably to its legacy.

SCENE OF KID'S HILL SKI RUN, C. 1960.
Miners and others had been skiing the region for decades when Austrian native Bruce Palmer strung a rope up a hill near downtown Telluride in 1932. His rope tow was well used by locals and the towing distance grew to 1,500 feet. Today Kids's Hill keeps its old name and ushers skiers from the foot of the Telluride Trail to Lift Eight, the Gondola, and Lift Seven—the first ski lift on the Town of Telluride side of the ski area.

JOHNNIE STEVENS AND STAN RICE ON ROPE TOW AT BALL PARK SKI RUN. As a young man, Johnnie Stevens, a native of Telluride, blazed trails for the ski area and later helped shape Telluride's identity as a ski resort, holding key positions in several companies that have operated the area over the years. Stevens was inducted into the Colorado Ski and Snowboard Hall of Fame in 2004.

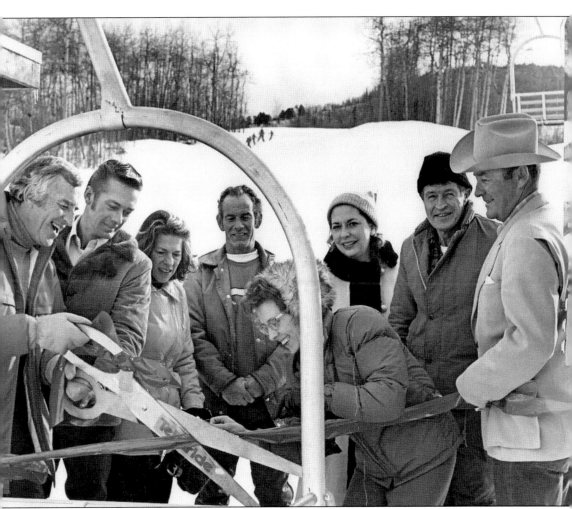

RIBBON-CUTTING CEREMONY FOR SKI-AREA OPENING, 1972. Joseph T. Zoline, a Los Angeles lawyer and businessman, bought property in 1955 near Aspen, Colorado. He had watched Aspen develop and when visiting Telluride in 1968 recognized its similar potential. Zoline and former Telluride miner William Mahoney Sr., a Telluride native and ski-area proponent, began making plans. French skier Emile Allais was hired to design the ski runs and Telluride locals cleared trails. The ski area opened in 1972 with 5 lifts, a day lodge, and 12 ski runs. The locals nicknamed Zoline "Joe Zoe." Mahoney, affectionately known locally as "Senior," a local historian, was inducted into the Colorado Ski Hall of Fame in 1997. Today Telluride is an international ski destination featuring unparalleled vistas, world-class ski terrain, a gondola transit system, 14 lifts, and much more. Zoline's initial investment was $10 million, and his vision still evolves today. Joe Zoline holds the ribbon-cutting scissors as Betty Ruth Duncan leans in to help. Next to Zoline, from left to right, are Raymond Fancher, Mrs. Zoline, William "Senior" Mahoney, Katherine Evans, Erban Hancock, and Gene Adams.

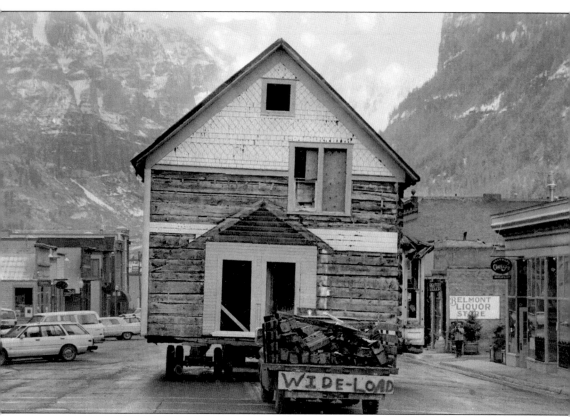

WIDE LOAD. By the late 1960s, Telluride's dilapidated commercial and residential neighborhoods invited newcomers to stake their claims, buying up inexpensive, abandoned houses. The burgeoning ski area accelerated development, and with each passing decade, property values have soared, making land in Telluride and the surrounding area as valuable as the gold and silver once reaped in the high country. It is, after all, a magical place of double rainbows in summer and sugar-fine snowfall in winter. The magnificent natural beauty of the area, Telluride's historic architectural landscape, the many summer and fall festivals, a thriving arts community, and a world-class ski area provide Telluride and her passionate residents an enviable quality of life. During the first Telluride Jazz Festival in 1977, famed musician Dizzy Gillespie had this to say, "If Telluride ain't paradise, then heaven can wait."

BIBLIOGRAPHY

Backus, Harriet Fish. *Tomboy Bride*. Boulder, CO: Pruett Publishing Company, 1969.

Barbour, Elizabeth. "Echoes of Yesterday." *Telluride Magazine*. Winter 1993–1994, Telluride Publishing Company, Incorporated, 1993.

Buys, Christian J. *A Brief History of Telluride*. Montrose, CO: Western Reflections Publishing, 2003.

———. *Historic Telluride in Rare Photographs*. Ouray, CO: Western Reflections Publishing, 1998.

Clifton, Alma Mary Midwinter. *As I Remember, The Midwinter's and Telluride*. Privately published, 1990.

Collman, Russ, and Dell A. McCoy. *The R.G.S. [Rio Grande Southern] Story: Volume II—Telluride, Pandora and the Mines Above*. Denver: Sundance Publications, 1991.

Duffy, Mary. "Telluride Depot." *Telluride Magazine*. Winter 2004–2005, Telluride Publishing Company, Incorporated, 2004.

Eggebroten, Evelyn Gustufson. *Memoirs of a Telluride Native*. Boulder, CO: Johnson Printing Company, 1999.

Fetter, Richard L. and Susan C. *Telluride "From Pick to Powder."* Caldwell, ID: The Caxton Printers, Limited, 1990.

O'Rourke, Paul. "Mountain Medics." *Telluride Magazine*. Winter 2003–2004, Telluride Publishing Company, Incorporated, 2003.

Spencer, Peter. "Power to the People." *Telluride Magazine*. Summer 1997, Telluride Publishing Company, Incorporated, 1997.

Wilkinson Public Library, complied by Pera, Davine. *Conversations at 9,000 Feet, A Collection of Oral Histories From Telluride, Colorado*. Ouray, CO: Western Reflections Publishing Company, 2000.

Williamson, Roger N. "The Great Telluride Strike." *Telluride Times*. September 1977.

DISCOVER THOUSANDS OF LOCAL HISTORY BOOKS
FEATURING MILLIONS OF VINTAGE IMAGES

Arcadia Publishing, the leading local history publisher in the United States, is committed to making history accessible and meaningful through publishing books that celebrate and preserve the heritage of America's people and places.

Find more books like this at
www.arcadiapublishing.com

Search for your hometown history, your old stomping grounds, and even your favorite sports team.

Consistent with our mission to preserve history on a local level, this book was printed in South Carolina on American-made paper and manufactured entirely in the United States. Products carrying the accredited Forest Stewardship Council (FSC) label are printed on 100 percent FSC-certified paper.

MADE IN THE